IMAGES
of America

FALL RIVER

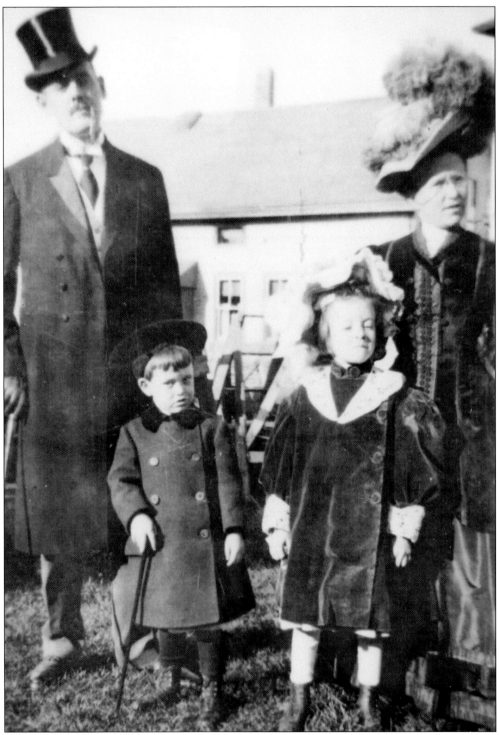

Here, Charles and Mary V. Leonard-O'Neil are pictured with their children, Charles and Helen, in 1909. The photograph was taken in the yard of their Park Street home. (Courtesy of Mary V. O'Neil.)

IMAGES
of America

FALL RIVER

Rob Lewis

ARCADIA
PUBLISHING

Published by Arcadia Publishing
Charleston, South Carolina

Printed in the United States of America

Library of Congress Catalog Card Number: Applied for

For all general information contact Arcadia Publishing at:
Telephone 843-853-2070
Fax 843-853-0044
E-mail sales@arcadiapublishing.com
For customer service and orders:
Toll-Free 1-888-313-2665

Visit us on the Internet at www.arcadiapublishing.com

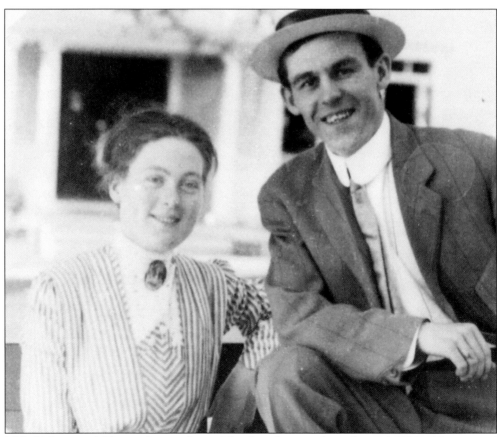

Mabel Moran and Thomas Leonard posed for this photograph in the mid-1890s. (Courtesy of Mary V. O'Neil.)

Contents

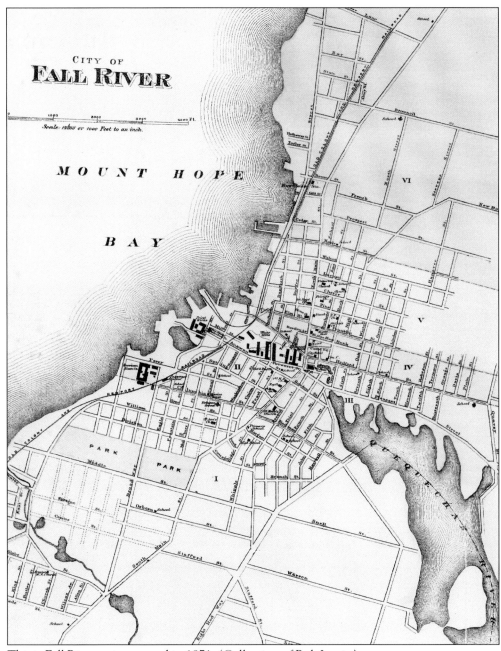

This is Fall River as it appeared in 1871. (Collection of Rob Lewis.)

Introduction

The place that we know as Fall River, Massachusetts, lies on North Latitude 41°42'04" and the West Longitude 71°09'20", approximately 45 miles south of Boston. Until 1659, the area between Aquidneck Island and Plymouth Colony was a vast wilderness. Like most of the Northeast, Fall River today is comprised of areas that served as permanent encampments for Native American tribes. They maintained a strong presence until after King Philip's War in 1676, when the Native American population in this section of the country was driven west or annihilated. At the beginning of the nineteenth century, Fall River was considered a small village of Freetown, consisting of less than one hundred people and about twenty dwellings. In 1803 Fall River was separated from Freetown and became its own village. The following year, on June 1, 1804, after petition to the general court, the name of the city was changed to Troy. For thirty years the name Troy was used, until February 12, 1834, when the name was changed back to Fall River, as it was thought that the old name had better recognition.

The development of Fall River was at first slow. The unprotected harbor was not the best, but the Quequechan River had a great flow, averaging over 26 million gallons per day, and the fact that it dropped 129 feet in less than 1/2 mile provided tremendous waterpower potential. The Native American name "Quequechan" translates to leaping or falling waters.

During the Revolution, the Battle of Fall River occurred on May 25, 1778, near the present site of today's city hall. On that day, a group of about one hundred and fifty British soldiers, led by Major Ayers, engaged Colonial troops that had organized in Fall River. The British were repelled, but on their retreat back to their ship, they burned Thomas Borden's grist and sawmill and set fire to several other dwellings.

The first stagecoach line that passed through Fall River, from Boston to Newport, was started in 1797. In the latter part of the 1800s, Fall River began to prosper as a major industrial city. Fall River granite could be quarried locally and was a fine, durable construction material. By 1840, over thirty men were employed in the stonecutting business, and that number almost tripled by the end of the century. In 1845 Fall River's first town hall was built, and by 1854 Fall River was incorporated as a city. The year 1862 brought a settlement to the conflict over the Fall River, Rhode Island, and the Fall River, Massachusetts border. The new state border was moved south, from Columbia Street to State Street after a ruling from the U.S. Supreme Court. Finally, all of Fall River was in Massachusetts. By the 1880s, the city could boast of the most modern conveniences, including streetcars, telephones, and electric service. In education, Fall River stood out from among her peers. The City provided free textbooks to its pupils ten years before the law required it, and when B.M.C. Durfee High School was opened in 1886, it was considered the finest in the nation.

As the city has developed, the very core of its mettle has been challenged many times. Several major fires have laid waste to the heart of the city, and each time Fall River has rebuilt, a testament to the strong will of her people. Even after the decline of the textile industry, Fall River remained a tightknit group of villages, and many of the old neighborhoods are still familiar today. The 1960s saw tremendous changes in the city. The Fall River many of us grew up in was cut in two by the new interstate highway, and two of the city's finest buildings, the Granite Block and the City Hall, were leveled to make way for the highway. It took ten years to rebuild the downtown district, and today it remains active during the week. The rescue and subsequent restoration of the Academy Building and the Durfee High School, combined with the redevelopment of the waterfront, has kept Fall River a growing, healthy community.

Please enjoy looking at this compilation of photographs of Fall River. Some of the images will bring on amazement with places of the past long gone, some may be familiar glimpses of our own pasts, and some are still to be found today proudly withstanding the test of time.

One

Downtown

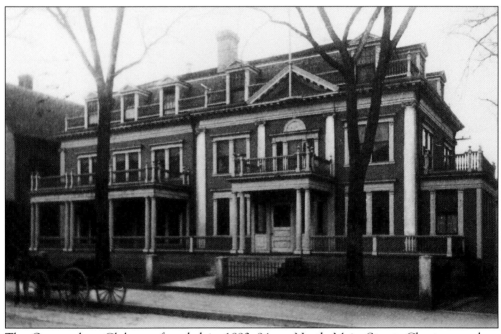

The Quequechan Club was founded in 1893–94 on North Main Street. Charter members obtained the William Mason house and remodeled it into a men's club. In 1919 the Wilbur house, adjacent to the club, was purchased, and the two were joined to enlarge the building. The club has been meticulously maintained inside and out.

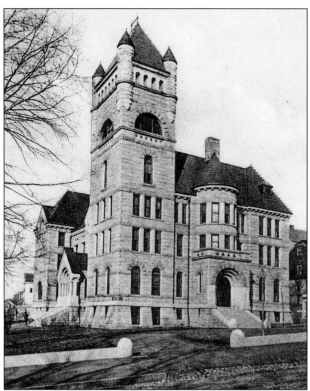

The Bristol Superior Courthouse, on North Main Street at the corner of Walnut Street, was built in 1889. In the early 1800s, the plot of land that it stands on was known as Deer Park. Prior to this location, trial was heard in the Borden Block and, before 1877, residents of Fall River had to travel to Taunton or New Bedford to go to court.

The YMCA was founded in 1857, suspended during the Civil War, and reactivated in 1868. The present building on North Main and Pine Streets was dedicated in 1903 and has served as an active YMCA since.

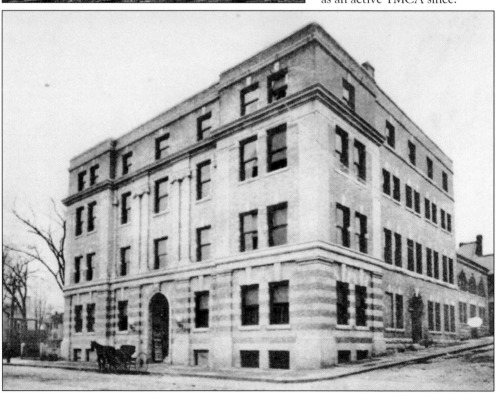

This is the First Baptist Church on North Main Street. The church was built in 1850. After the 1843 fire that burned through the business district, people began to move out of the downtown area. This location was part of the new expansion to the east and northeast.

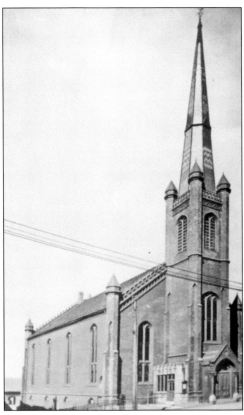

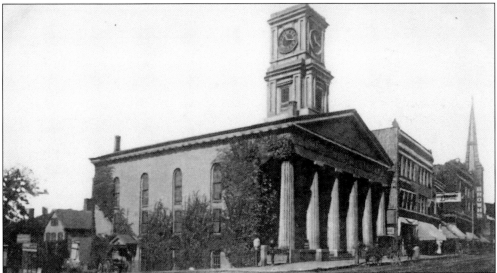

Pictured here is the First Congregational Church on North Main Street. The first church was organized in January 1816, and it met at members' homes and in a schoolhouse. In 1822 a church was built on Anawan Street and then enlarged in 1827. The church in the photograph was erected on North Main Street in 1832 and was known as the stone church. The noted historian Orin Fowler served as pastor of the congregation from 1831 until 1850. The E.S. Brown store is visible just past the church. (See page 92.)

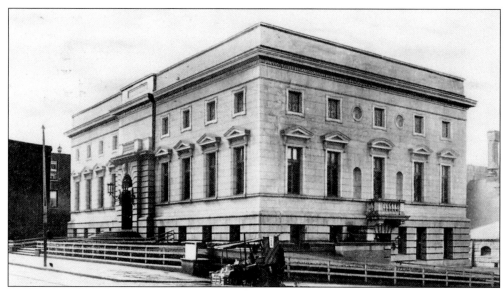

This is the Fall River Public Library. The first library was the Fall River Athenaeum, a private library organized in 1835. After the 1843 fire, it was relocated to the Market Building. In 1860 the Fall River Public Library was formed and had its residence in the city hall. After the 1886 fire, the Mary Young estate was donated to the City, and on this site the present structure was built and opened in March 1899.

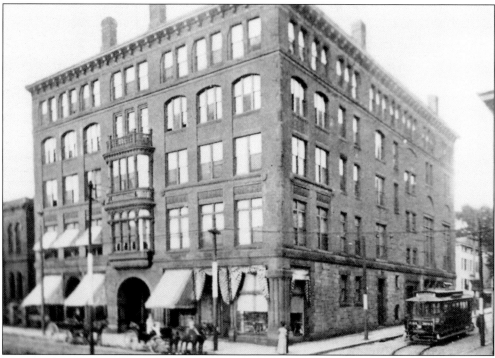

The Hotel Mellon was located on the corner of North Main and Franklin Streets. The structure was built in 1888 and was used as a hotel until 1962, when it was put into service as the temporary city hall. It was razed shortly after 1976, upon completion of the new city hall spanning route I-195. (Courtesy of Fall River Public Library.)

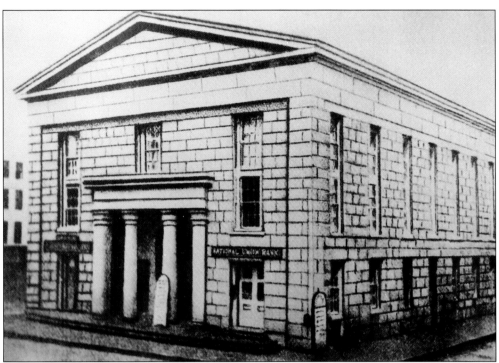

The earliest town hall was located in Steep Brook, near what is now the end of North Main Street, past Border City. In 1844, after the destruction from the fire of 1843, a new town hall was built on Main Street, on land purchased from the Pocasset Mill Company. The city prospered, and in 1872 the building underwent extensive remodeling. The Market Building, in the picture above, stood where the city hall stands today. (Courtesy of Fall River Public Library.)

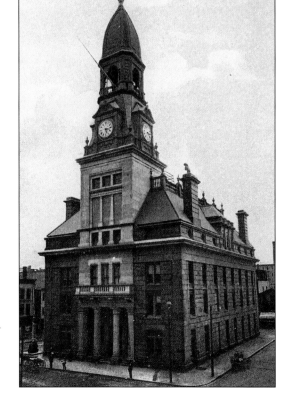

Pictured here is the city hall on Main Street. After the 1886 fire, the badly damaged city hall sat empty for four years. Finally, in 1890 it was remodeled in the manner in which it is pictured here. The building kept its appearance until it was torn down in the 1960s.

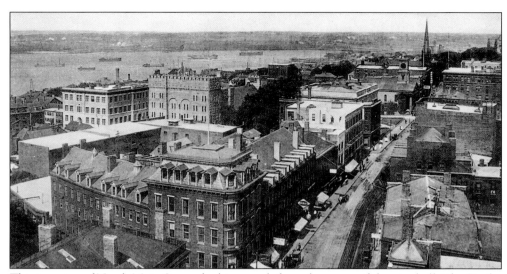

This is a view of North Main Street, looking north from the tower of the city hall. The Durfee Block was located on the corner of North Main and Central Streets. The city's first telephone exchange was in the Borden Block. The exchange opened in 1879 and carried 112 subscribers. In 1890 the service was moved to a facility built for the phone company. In the distance we see the armory (on the right) and the textile school (on the left).

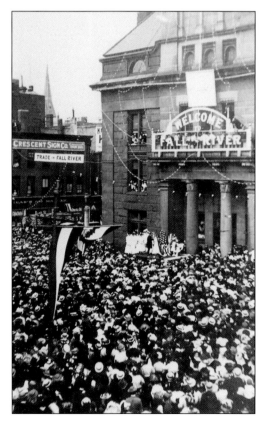

In this photograph of the opening day of the Cotton Centennial, June 19, 1911, the mayor is shown crowning the carnival queen, Miss Marion Hills. (Photo courtesy of Fall River Public Library.)

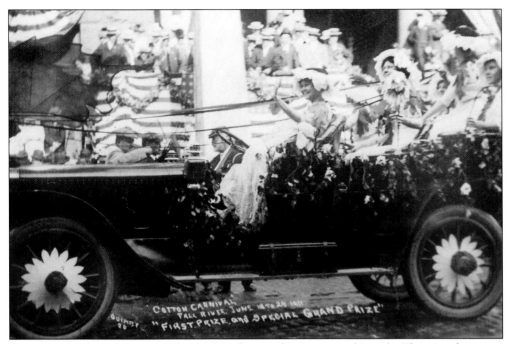

This automobile took first prize for the best float in the Centennial Parade. The 1911 festivities began on June 19 and ended on June 24.

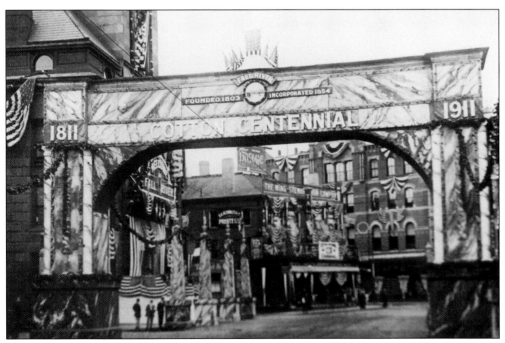

The Cotton Centennial Memorial Arch was erected in City Hall Square in 1911. The week-long festival was to celebrate the hundred-year history of cotton and the textile industry in the city. A parade, fireworks, and a visit from President Taft were a few of the highlights of the celebration. (Courtesy of Fall River Public Library.)

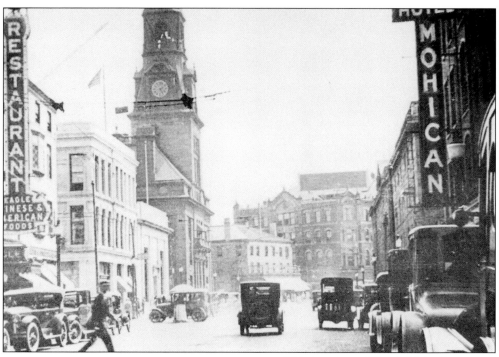

This is a view of North Main Street, looking south toward the city hall before the 1928 fire. On the left is the sign for the Eagle Restaurant, and on the right is the sign for the Mohican Hotel. The Mohican opened in 1914 under the management of William Durfee and could accommodate five hundred guests. The hotel was destroyed in the 1928 fire. (Courtesy of Fall River Chamber of Commerce.)

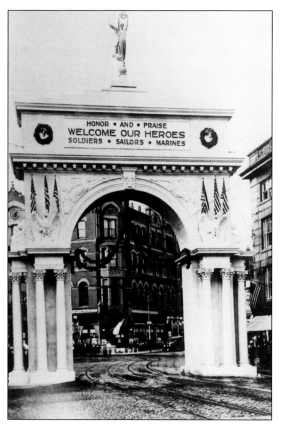

The Welcome Arch was built in 1919 in City Hall Square. The arch, also called the Victory Arch, was erected for the November 11, 1919 celebration to welcome home veterans from World War I. (Courtesy of Fall River Public Library.)

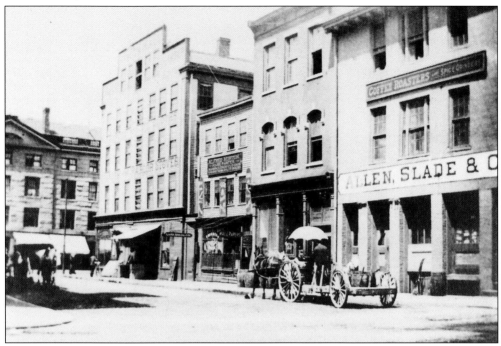

Pictured here is Market Square, from Bedford to Pocassett Streets. Allen, Slade & Company were wholesale grocers and coffee roasters. The business was started in the mid-1860s. (Courtesy of the Dominican Sisters archive.)

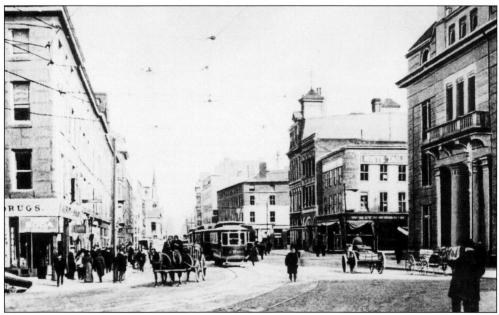

This is a postcard view of City Hall Square. The city hall is seen to the right, and the Granite Block is seen to the left of the photograph. In 1880 the first streetcar rails were laid. The cars were first pulled by horses, but by the early 1890s, the system was electrified. By the end of the century, most of the city was accessible by streetcar. The streetcars operated until 1936. (Courtesy of Deb Collins.)

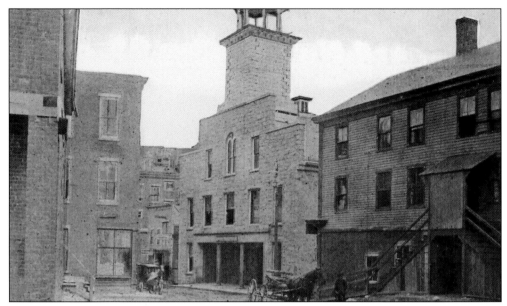

The Central Police Station in Court House Square was erected just before 1843 for use as stables. In 1857 it was remodeled to house the police department, which had outgrown its Market building location. This building stood until the early 1900s. (Collection of Rob Lewis.)

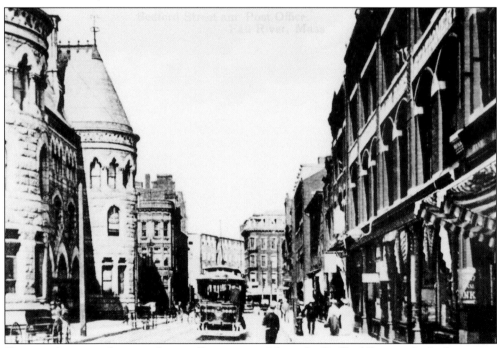

Here are the customhouse and post office as viewed from the Bedford Street side, looking west. The first postal service was started in 1811, and the first free delivery began in 1863. (Collection of Rob Lewis.)

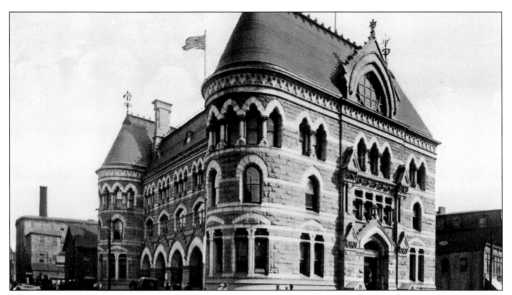

This magnificent building was designed by William A. Potter. It was built from 1875 to 1880, and was operated as a customhouse and post office until the 1930s, when it was razed to make room for the structure that stands today. The medallions from the front of the customhouse are housed at the Fall River Marine Museum. (Collection of Rob Lewis.)

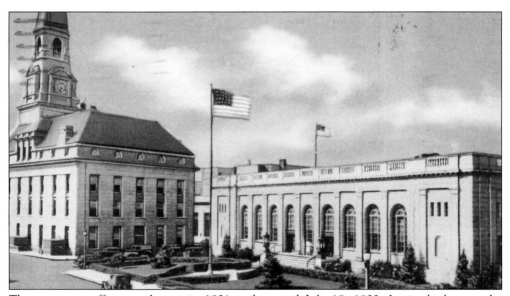

The new post office was begun in 1931 and opened July 18, 1932. It was built over the Quequechan River, as was the old post office.

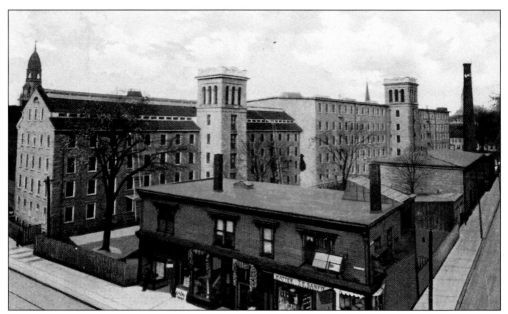

The Troy Mills were built in 1814, spanning the Quequechan River directly behind the city hall. After a fire in 1821, the mill was rebuilt, and in 1860 a new five-story complex was built, which we see pictured here. Oliver Chace was the driving force behind the Troy Cotton and Woolen Manufactory, which he ran from 1814 until 1822. (Collection of Rob Lewis.)

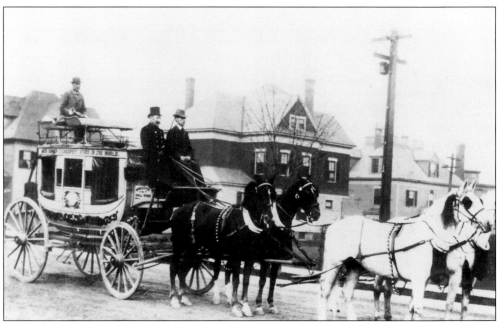

Around the turn of the century, a horse-drawn carriage advertised the Troy Store.

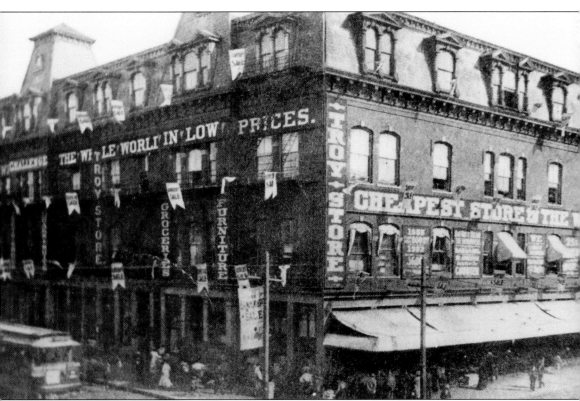

The Troy Store was located on Pleasant Street at the corner of Fourth Street. The store advertised itself as "the world's cheapest store." It operated until the 1930s, when the building was demolished. The store carried everything from clothing to sundries. At one time, patrons departed from a landing at the rear of the store and were taken by barge up the Quequechan River to a pine grove known as Adirondacks, on the North Watuppa, where a picnic was arranged on the shore of the pond. (Courtesy of the Fall River Public Library.)

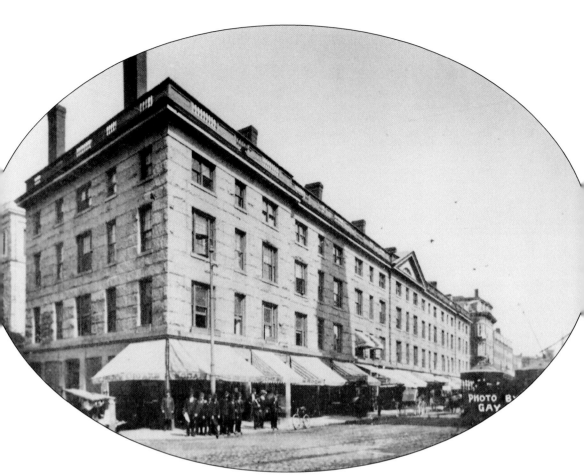

The first Granite Block was built on the west side of Main Street, between Pocassett and Central Streets, after the 1843 fire. It was four stories tall and was a center of activity until it was destroyed by the 1928 fire that tore through the business district (see page 108). (Courtesy of the Dominican Sisters archive.)

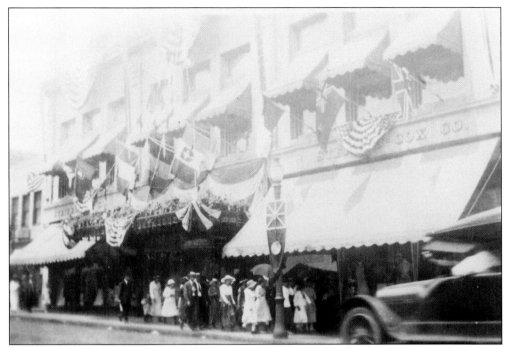

After the great conflagration of 1928, this new three-story Granite Block was built on the site of the original. This building stood until the early 1960s, when it was razed to make way for route I-195. (Courtesy of Jim McKenna.)

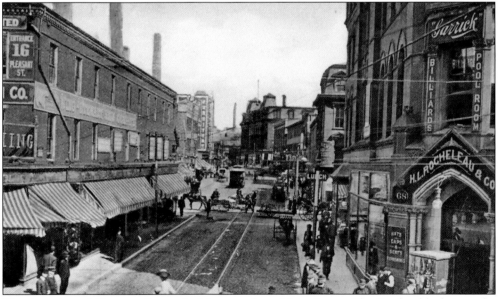

This is a view of Pleasant Street, looking east from Main Street. The Borden block is to the right. It was built in 1875, was designed by Hartwell and Swazey, and was named after Nathaniel Borden. In January 1876, the Academy of Music, located in the Borden block, opened its doors, and for years hosted live concerts and performances. In the late 1920s the structure was turned into a movie theater. Today the building is on the National Register and has been renovated for multi-purpose occupancy. (Collection of Rob Lewis.)

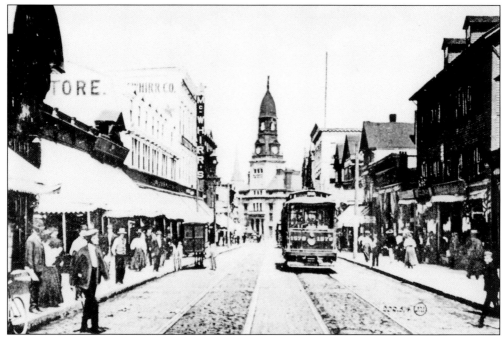

In 1877 the McWhirr Store was founded near Charity Lane, by Robert A. McWhirr and Sarah Ramsay. In 1886 it moved to South Main Street and after the 1916 fire, was rebuilt with twenty times more floor space. The store closed in the 1970s, and the building was razed in 1981.

In this photograph, the author conducts his first interview for the Fall River book in December 1956. Anyone growing up in the city can probably remember a visit to the McWhirr's Santa Claus during the holiday season. (Collection of Rob Lewis.)

Two

Fall River
Institutions

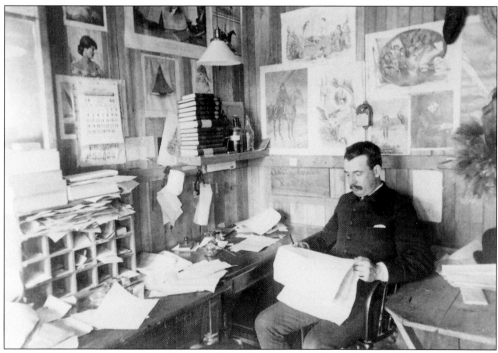

Pictured here in 1885 is James Dennan O'Neil, managing editor of the *Fall River Daily Globe*. The *Fall River Globe* was a Democratic newspaper established in 1885. The paper was first located in a building in Old Court Square. In 1906 the business moved to new quarters on North Main Street. It was absorbed by the *Fall River Herald News* in February 1929. (Courtesy of Mary V. O'Neil.)

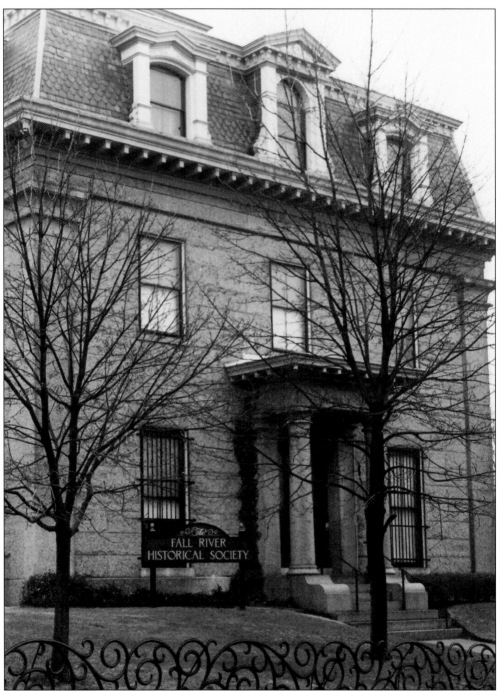

This is the Andrew Robeson house on Rock Street, home to the Fall River Historical Society. The house was originally built on Columbia Street in 1843, three-fourths in Massachusetts and one-fourth in Rhode Island. In 1870 it was moved piece by piece to its present location, and in 1936 it was given to the Fall River Historical Society, which maintains it as a museum of local history. The museum also houses a large collection of Lizzie Borden memorabilia. (Photograph by Rob Lewis.)

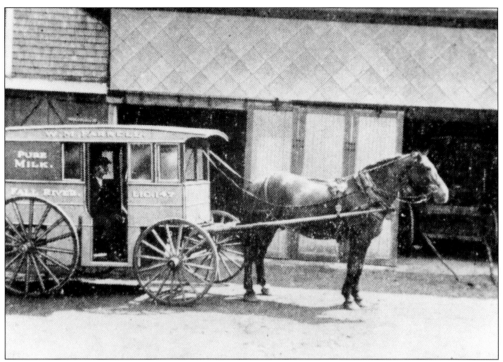

This photograph shows the delivery wagon for the Warren M. Farrell Milk Company. The plant was located at 143 Bigelow Street. In 1919 the company advertised pasteurized milk for babies, as well as a telephone connection. (Courtesy of Jim McKenna.)

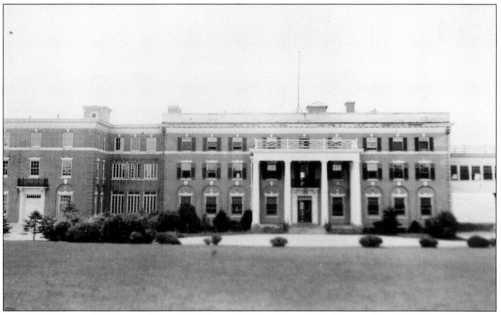

In 1905 Doctor Philemon Truesdale founded the Truesdale Hospital on Highland Avenue and oversaw its operation until 1945. This building was erected in 1926. In 1980 the hospital merged with the Union Hospital to form Charlton Memorial Hospital. Today the building houses a senior residential community.

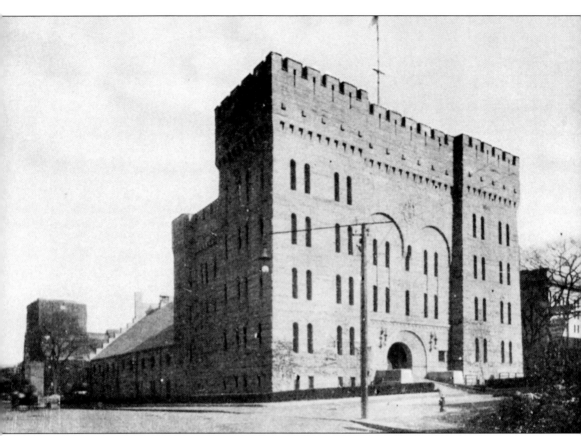

The Armory on the corner of Bank and Durfee Streets was completed in 1897 at a cost of $150,000 and served as an armory until the late 1950s, when the Dwelly Street facility opened. Today the old Armory houses community offices. (Collection of Rob Lewis.)

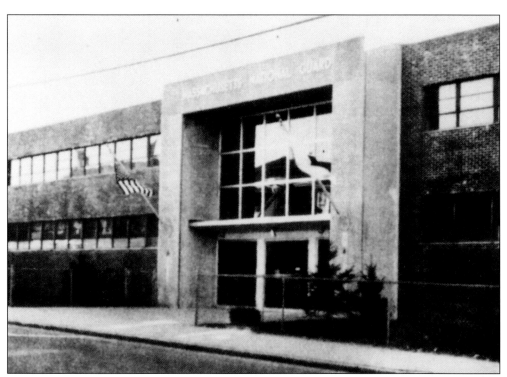

Pictured here is the Dwelly Street Armory shortly after it was dedicated on May 30, 1958. (Courtesy of Ed Depin.)

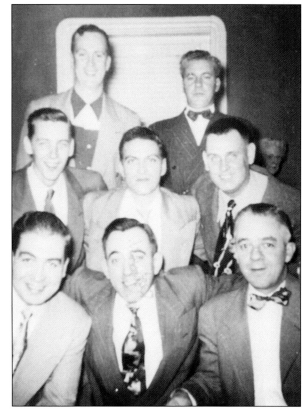

These men were part of the first battalion to occupy the Dwelly Street Armory. They are, from left to right: (first row) John Oliveira, Chris Oliveira, and Eddy Shea; (middle row) Ken Depin, Joe Cabral, and Ed Depin; (back row) Dave Burns and Nick Demarco. (Courtesy of Ed Depin.)

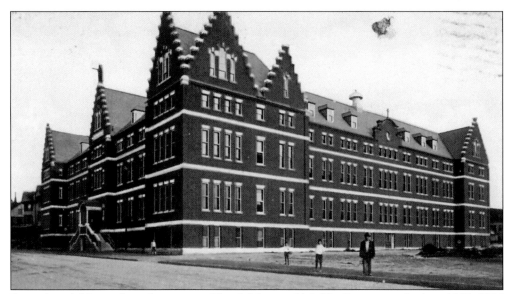

Saint Anne's Hospital, on the corner of South Main and Middle Streets, was built in 1905–1906 and was dedicated on February 4, 1906. The hospital was paid for and staffed by the Dominican Sisters of Charity. When it opened, the hospital consisted of five wards—three female and two male—and could care for one hundred twenty-five patients. (Courtesy of the Dominican Sisters archive.)

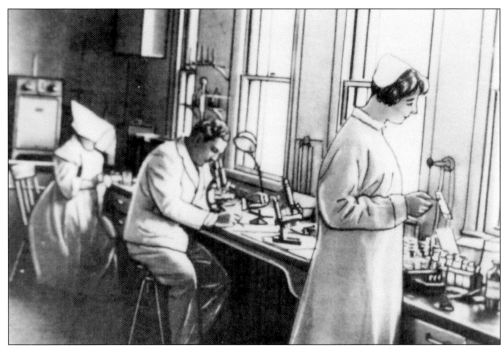

This is a postcard view of Saint Anne's modern laboratory in the early part of the 1900s. (Courtesy of the Dominican Sisters archive.)

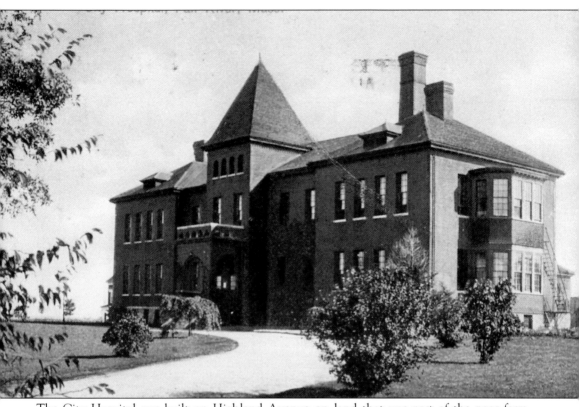

The City Hospital was built on Highland Avenue on land that was part of the poor farm. When it opened, the hospital was staffed by six medical doctors and six surgeons, and it provided a general hospital, a contagious disease ward, and a tuberculosis ward. (Collection of Rob Lewis.)

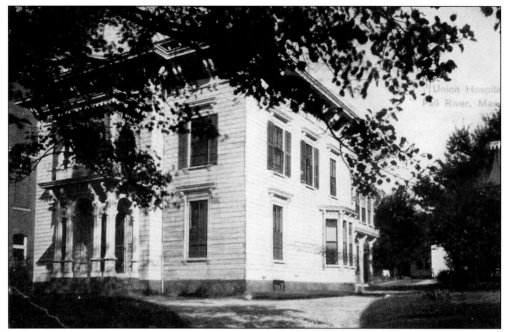

The Fall River Hospital, on Prospect Street, was founded in 1885, and the first patient was admitted to this building in May 1888. In 1900 it became Union Hospital, after joining with the Emergency Hospital. (Collection of Rob Lewis.)

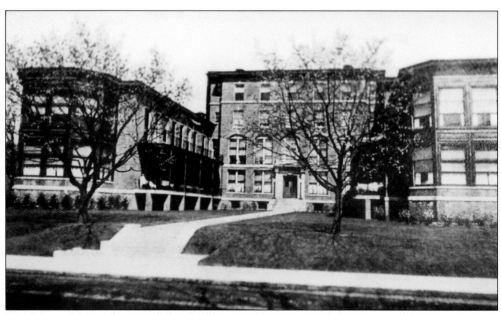

The Union Hospital erected this building on the corner of Prospect and Hanover Streets in 1908. Today the building serves as the surgical center for Charlton Memorial Hospital. (Courtesy of Fall River Public Library.)

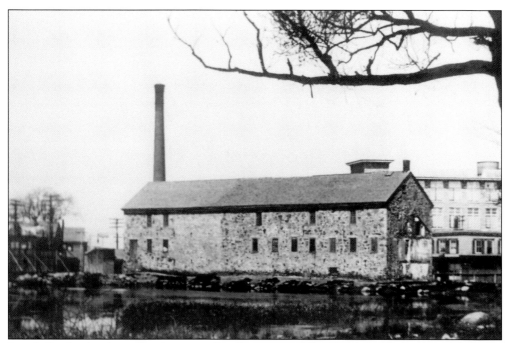

Joseph Durfee fought in the American Revolution in 1777. After fighting in New York, he set up a watch in Fall River that turned back British forces in the Battle of Fall River. After the war, he moved to Tiverton and built the area's first cotton mill (pictured above) in 1811.

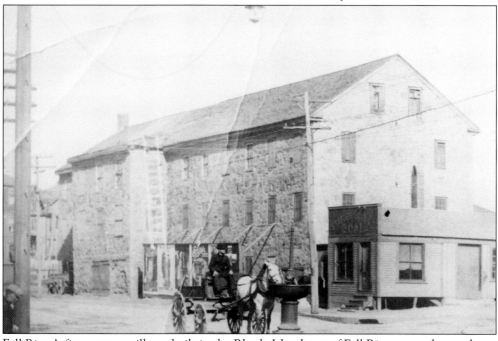

Fall River's first cotton mill was built in the Rhode Island part of Fall River, near the northeast corner of South Main Street and Globe Street. The mill was built on Globe Pond and operated until 1829, and then served other industrial uses until it was torn down around 1912. Globe Pond was eventually filled in, and today the area is known as Father Kelly Park.

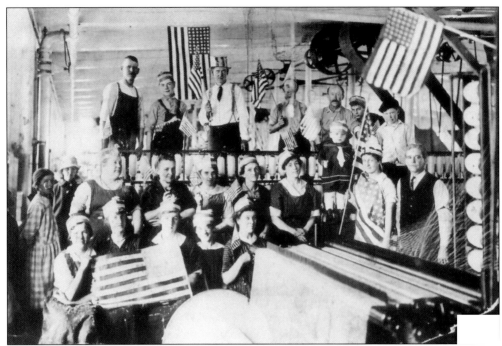

Ann V. Rogers-Loftus, wearing flag, and co-workers at the Kerr Thread Mill (see page 112) were photographed on July 4, 1912. (Courtesy of Kate Wheeler.)

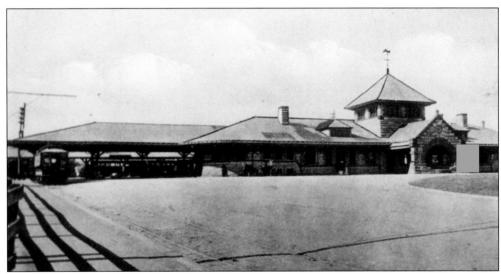

This is the Fall River stop on the New York, New Haven, and Hartford railroad line. The station was located near the intersection of North Main Street and President Avenue. It was built in 1891 and was the city's main station, serving both passenger and freight lines and operating until the decline of rail service. It was demolished in 1953. (Courtesy of Fall River Public Library.)

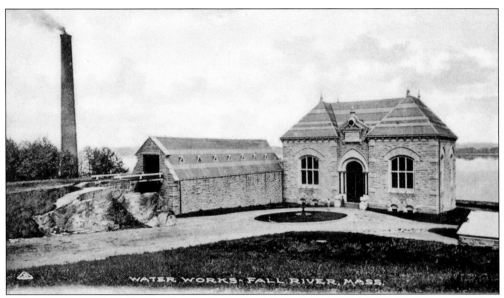

In the early 1870s, a public works commission was formed, and in 1872 a new water works plant was constructed at the top of Bedford Street, on the North Watuppa Pond. The works consisted of a pump house, filtration system, and a gate house 200 feet from shore, assuring a clean and abundant supply of water year round. The pond could supply over 30 million gallons per day when at full capacity.

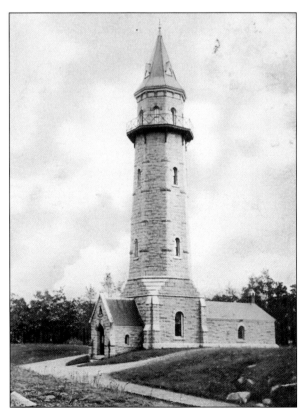

This tower was built above the pumping station. It stands 121 feet tall and its balcony is 324 feet above sea level, lending a spectacular view on a clear day.

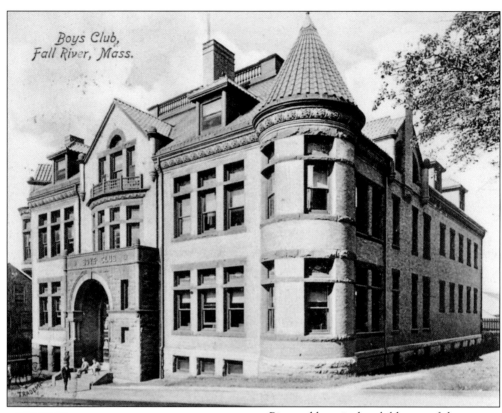

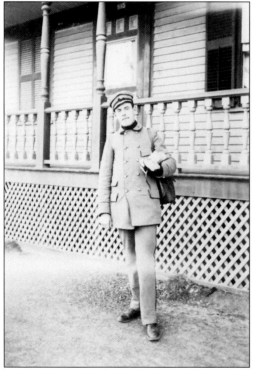

Pictured here is the clubhouse of the Fall River Boys Club on Anawan Street. The first club, organized in 1890, quickly outgrew its home, and in 1898 this imposing structure was built through the generosity of Matthew C.D. Borden. In 1969 the Thomas Chew Memorial Boys Club was built on Bedford Street, and this building was demolished shortly after.

A Fall River letter carrier, Charles E. O'Neil, is pictured on his route shortly after the turn of the century. Mr. O'Neil served as a postman from 1895 until his retirement in 1937. (Courtesy of Mary V. O'Neil.)

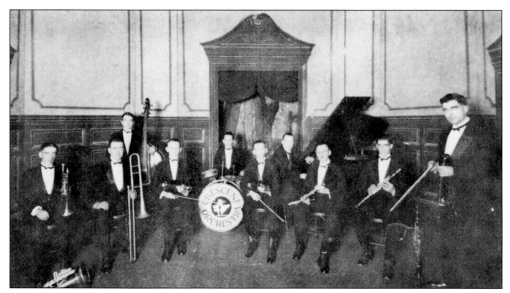

The Crescent Orchestra is shown in this photograph from the 1920s. A very popular local band, they played at the inauguration soiree of Saint Anne's School in 1925. (Courtesy of the Dominican Sisters archive.)

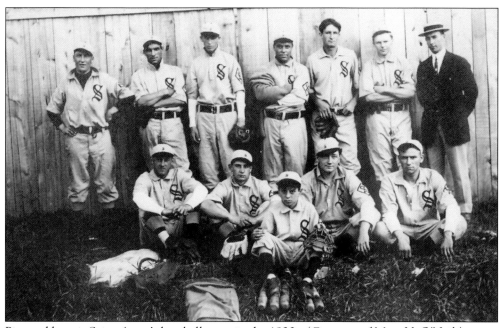

Pictured here is Saint Anne's baseball team in the 1920s. (Courtesy of Mary V. O'Neil.)

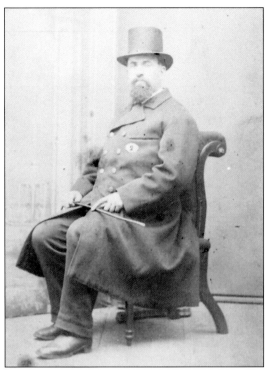

Dennis O'Neil was born in Ireland in 1825 and moved to Fall River in 1844. He is pictured here around 1875, while serving as city messenger, a position appointed by the mayor. He was messenger from 1873 until 1877, and he then held a position with the Old Colony Railroad for forty years. He died peacefully at home in 1904. (Courtesy of Mary V. O'Neil.)

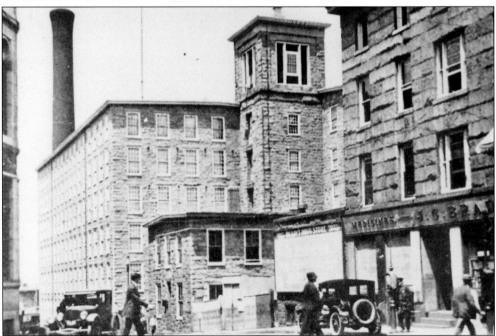

The mill in the center of the photograph was part of the Pocasset Manufacturing Company, a complex of mills that spanned the Quequechan River just west of the Granite Block. The company was organized in 1822 and operated until 1926. Two years later, in 1928, a fire started in one of the mills that devastated the business district (see chapter nine). (Courtesy Chamber of Commerce.)

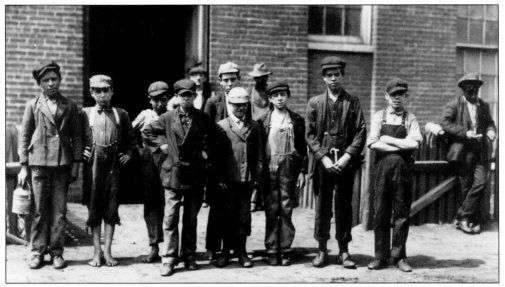

Lewis Hine started his photography career by documenting conditions on Ellis Island. In 1912 he photographed the working conditions and people in mills throughout southeastern Massachusetts, especially Fall River and New Bedford. Here, he has photographed underage mill operatives at the Sagamore Manufacturing Company. (Lewis Hine photograph courtesy of the National archive.)

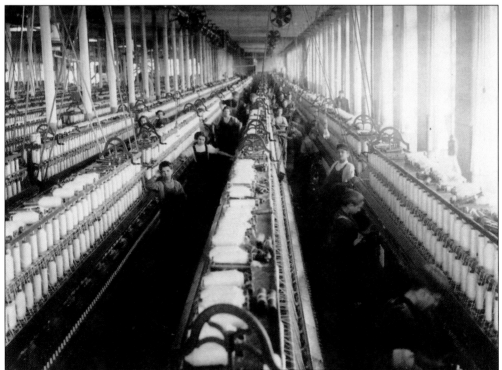

This Hine photograph is of the spinning room at the Cornell Mill. The mill was organized in 1889 and had a capacity of 45,000 spindles. It operated until 1930. (Lewis Hine photograph courtesy of the National archive.)

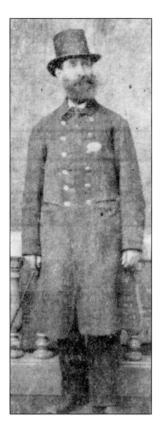

William E Wrightington is pictured in 1854. Wrightington was the first uniformed police officer in the city. He was born in November 1824, and when he was thirty years old, he joined the Fall River Police Department, where he served for eighteen years. In 1854 the force consisted of seven day and eight night men. The chief constable was paid $10.50 a week, and watchmen were paid $8.50 a week. (Courtesy of Fall River Police Department.)

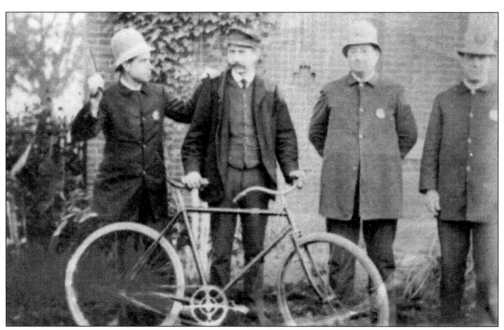

In 1874 the city was divided into four districts. This 1902 photograph shows officers from precinct number 2, in the north end. (Courtesy of Fall River Police Department.)

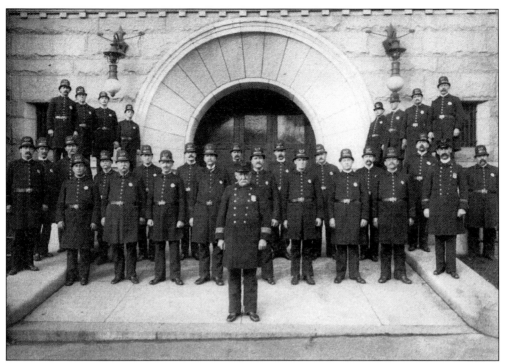

Members of the Fall River Police Department pose in front of the armory on Bank Street at the turn of the century. (Courtesy of Fall River Police Department.)

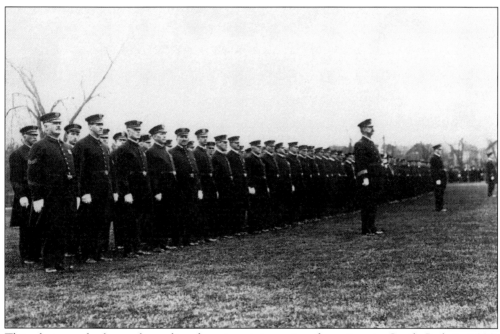

This photograph shows the police department in review formation in South Park in 1920. (Courtesy of Fall River Police Department.)

This photograph of an early traffic stand is from a worldwide web site that the Fall River Police Department maintains. (Courtesy of Fall River Police Department.)

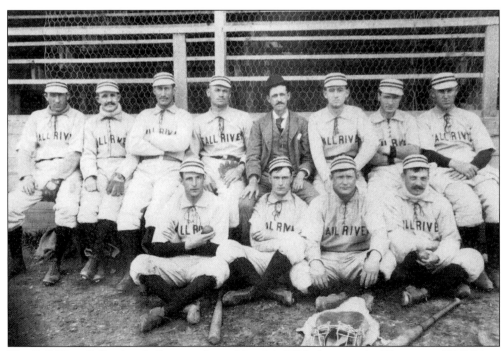

The Fall River Police baseball team of posed for this 1920 photograph. (Courtesy of Fall River Police Department.)

Three

The Waterfront

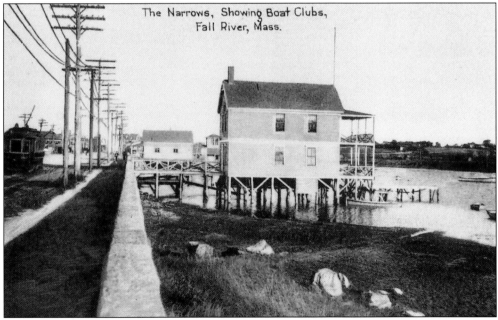

The Narrows, Showing Boat Clubs,
Fall River, Mass.

This postcard features a view along the "Narrows," a thin strip of land between the North and South Watuppa Ponds. During the late 1800s and early 1900s, the Narrows was a popular area for picnics and outings.

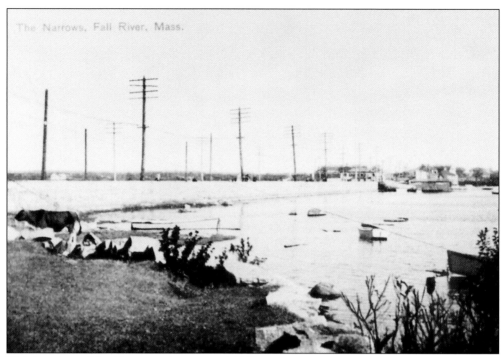

This is a view of the Narrows taken around 1900.

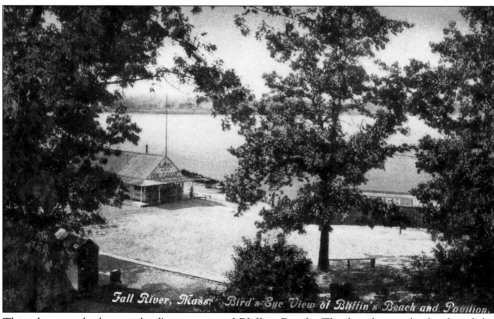

This photograph shows a bird's-eye view of Bliffins Beach. The beach, on the banks of the Taunton River at Steep Brook, was popular from around 1900 until the 1930s.

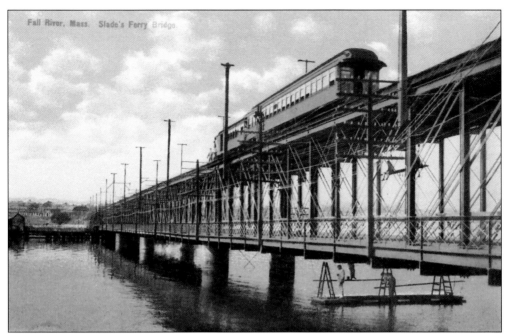

The Slades Ferry Bridge was built in 1875 to span the Taunton River and provide direct access to Somerset and the road to Providence. The site was originally the Slades Ferry Landing, a ferry service dating back to the late 1600s. The bridge was 955 feet long, with the upper deck serving trains and the lower level carrying pedestrian and carriage passage. The bridge was opened in 1875 and was in service until 1970. It was torn down shortly after.

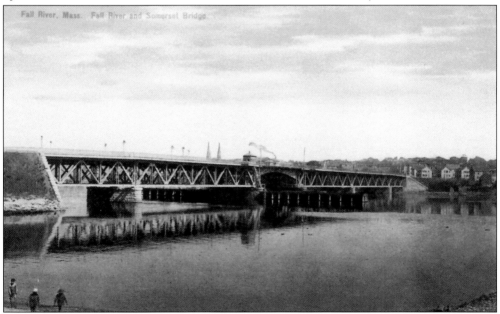

The Brightman Street bridge was authorized by the legislature in 1903, begun in 1906, and opened October 10, 1908. The span is 922 feet long and 60 feet wide. At the time it was built, the bridge cost $1,014,102. On the banks of the river, adjacent to where the bridge stands was once the location of a permanent Native American encampment.

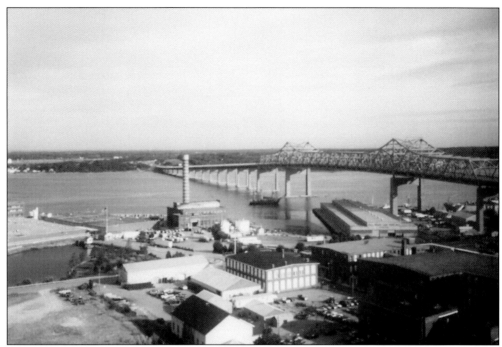

The Braga Bridge was started in 1959 and opened in the spring of 1966. The bridge was originally known as the Taunton River Bridge and was renamed after Charles Braga Jr., a Fall River native who lost his life in the attack on Pearl Harbor. The bridge spans 1.2 miles and cost $25 million to build. (Photograph by Ed Depin.)

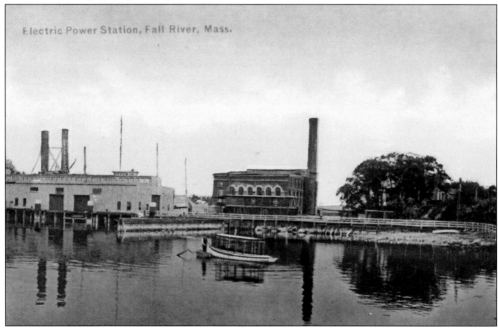

The Fall River Electric Light Company was formed in 1883 and operated on Hartwell Street for many years. This plant was built in 1906 on Hathaway Street and was in service until the 1940s, when it was replaced by the Montaup plant .

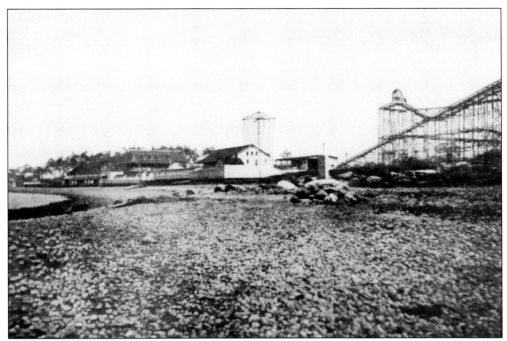

Pictured here is Sandy Beach, located at the end of Bay Street. Before the 1890s, the area was known as Old Elm. Around 1892 the Dubois family developed the area into an amusement park and bathing spot. The beach was very popular and could be reached by trolley from almost anywhere in the city. (Courtesy Fall River Public Library.)

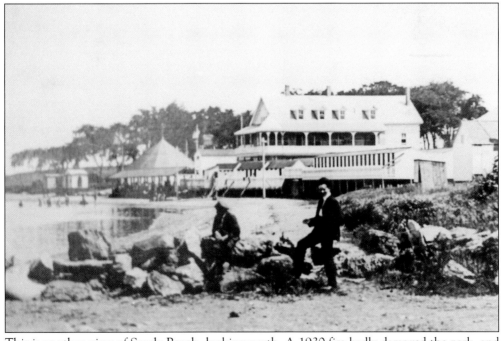

This is another view of Sandy Beach, looking north. A 1930 fire badly damaged the park, and the hurricane of 1938 finished the destruction. (Courtesy of Fall River Public Library.)

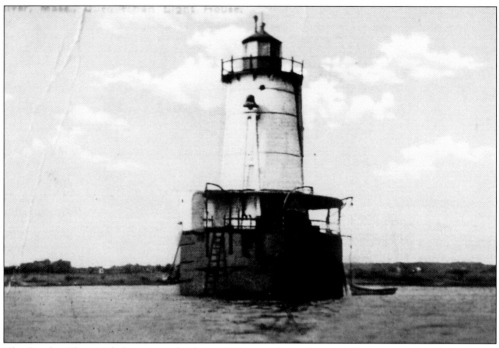

The Borden Flats Lighthouse was built in 1880 to replace a beacon that operated in this spot. A lighthouse keeper tended the light until 1937, when the lighthouse was automated.

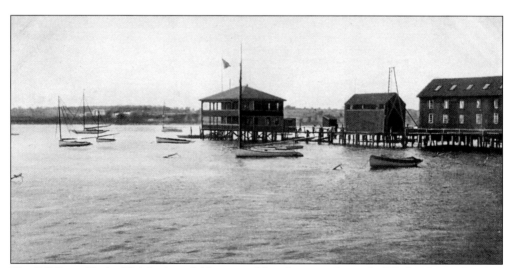

The Fall River Yacht Club had its clubhouse and boathouse at the end of Taylor Street. In 1912 the city directory listed Jabez Wilkinson as commodore. Today Point Gloria inhabits the site.

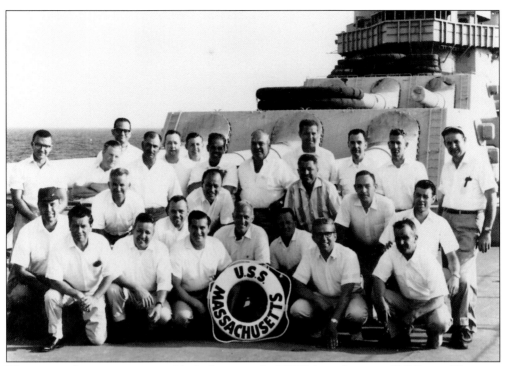

This group of men were responsible for bringing the USS *Massachusetts* to Fall River. (Courtesy of Deb Collins.)

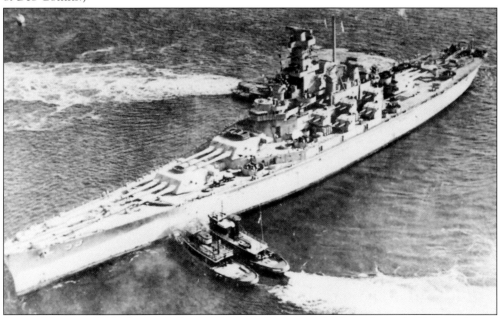

Pictured here in 1965, the battleship USS *Massachusetts* was built in the early 1940s and went immediately into battle, seeing action in both the Atlantic and Pacific Theaters. She is 680 feet long and weighs 35,000 tons. The ship was mothballed in 1947 for fifteen years, and when she was in danger of being scrapped, funds were raised to bring the ship to Fall River. (Courtesy of Deb Collins.)

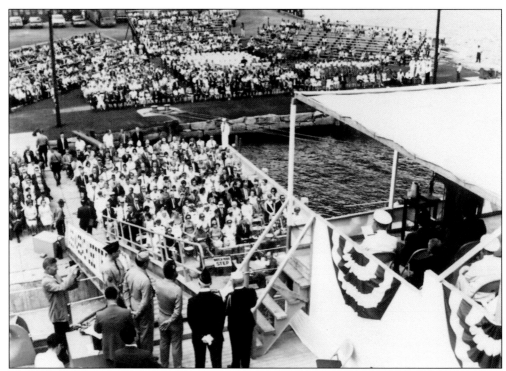

This photograph from 1965 shows the rededication of "Big Mamie" at Battleship Cove. (Courtesy of Deb Collins.)

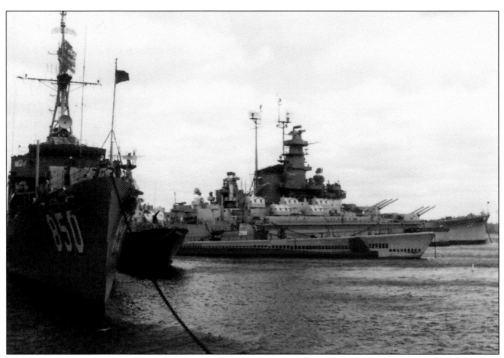

This is Battleship Cove as it appears today. (Photograph by Rob Lewis.)

Four

The Quequechan River

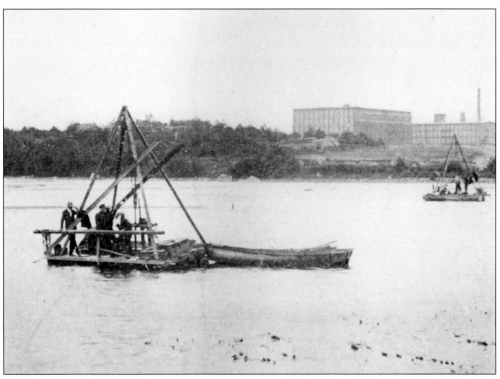

Here, a crew prepares to take test borings of the riverbed in a survey prior to the overhaul of the water system. In 1914, two hundred and forty-six test borings were taken along the Quequechan River. In this photograph the barges are below the sandbar at the southeast end of the river.

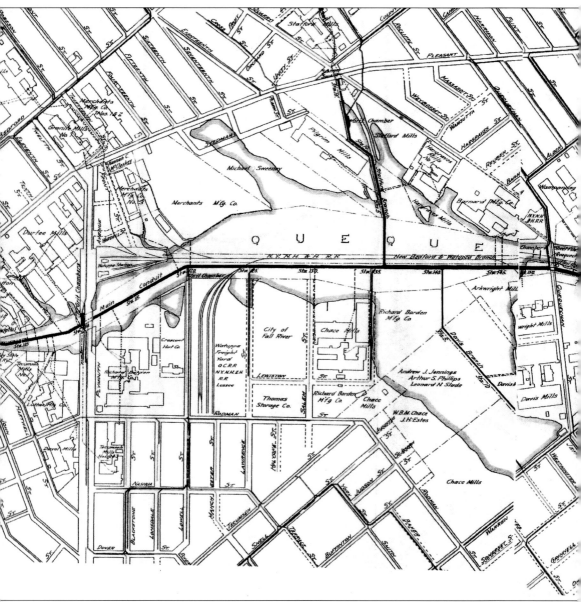

This map was part of a report presented to the Watuppa Ponds and Quequechan River Commission on September 8, 1915. The photographs in this chapter are part of that report. They offer unique glimpses of a river that disappeared from our landscape in the 1960s.

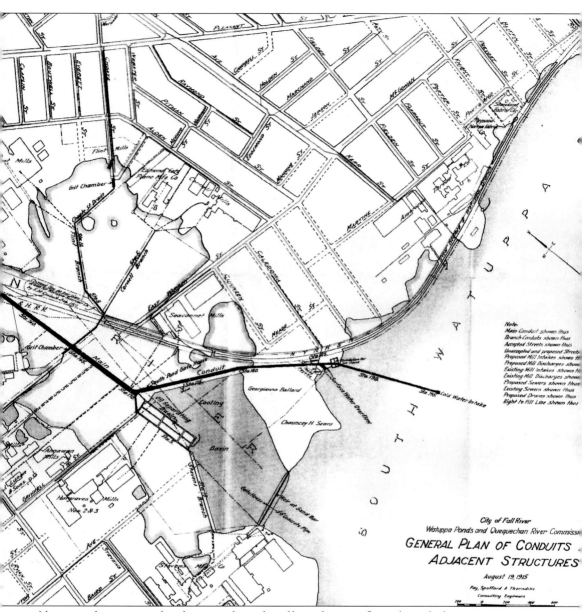

I have tried to arrange the photos in the order of how the river flows through the city on its way to the bay.

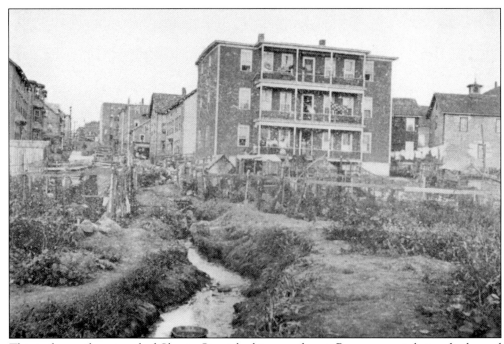

This is the southwest end of Choate Street looking northeast. Raw sewage is being discharged into the Quequechan River. The date is October 1914.

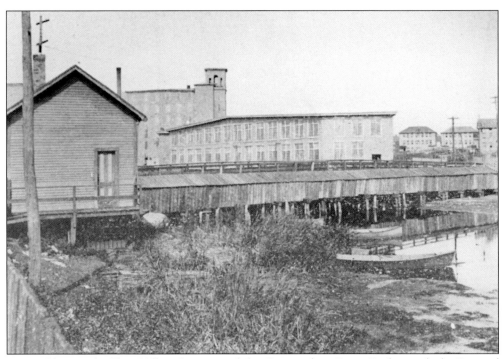

Pictured here is the Flint Village Station and the Quequechan Street Bridge, with the Barnard Manufacturing Company in the distance.

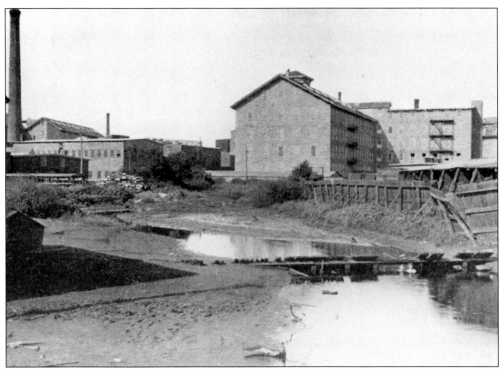

This photograph shows a discharge basin located at the foot of Front Street. By looking closely at the bottom of the picture, two boys can be seen bathing in the water. Before sewage lines were extended to all parts of the city, cesspools were emptied by using a bucket at the end of a long pole and the refuse carted away in buckboards called honeycarts.

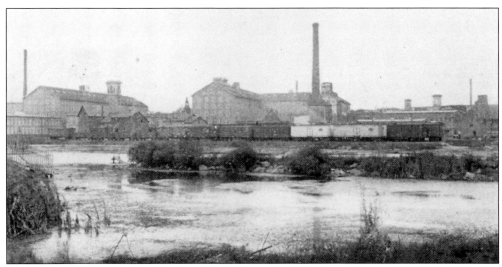

This photograph shows a view across the Quequechan looking at the area of 14th and Pleasant Streets. A windmill once stood to the right of the picture. This 1914 photo shows Watuppa Train Station with the Durfee Union Mill Complex in the background.

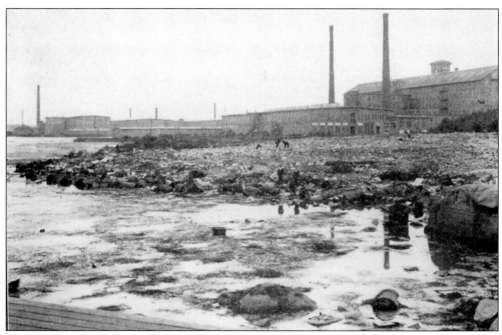

The city dump was located between Lawrence and Salem Streets. Today, the city incinerator and city yard are located here.

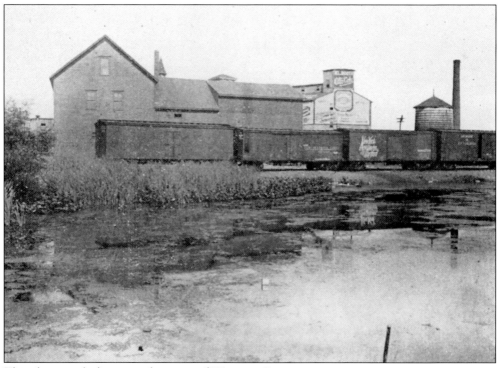

This photograph shows another view of Watuppa Station.

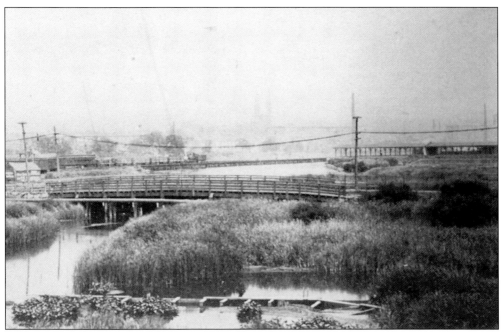

This 1914 image shows the Plymouth Avenue bridge. Originally, the street was known as Eight Rod Way. In the 1870s, this bridge was constructed and the road was extended to Pleasant Street. The New York, New Haven, and Hartford Railroad station is visible beyond the bridge.

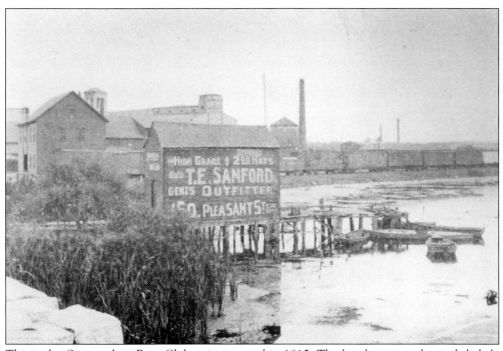

This is the Quequechan Boat Club as it appeared in 1915. The boathouse was located slightly east of the Plymouth Avenue bridge.

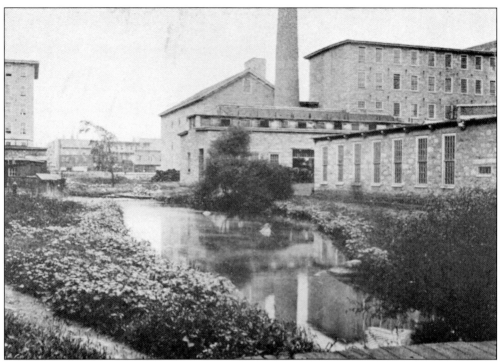

Shown here is a discharge basin running along Blossom Avenue. The basin served the Union and Durfee Mills, which are visible in the photograph.

Pictured here is the river, just up from Watuppa Dam. In the center of the photograph, a privy overhangs the channel. The large building to the left is the rear of the Troy Store.

Here, privies are shown at the south end of Blossom's Avenue in October of 1914. The Massasoit Manufacturing Company and the Union Cotton Mills are in the distance.

In this photograph of the Troy Mill Pond at the Pleasant Street bridge, the Troy Store can be seen in the middle of the picture.

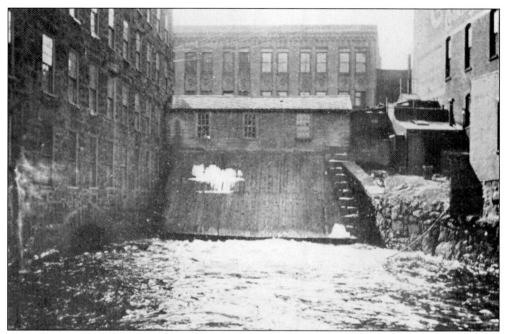

This photograph was taken below the Troy Dam in 1915. The Troy Dam was built in 1813 as a part of the Troy Mill Complex. In the 1960s, it was destroyed and the river was diverted underground through large conduits.

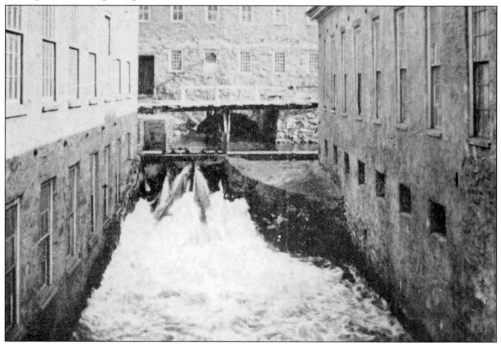

This photograph was taken along the Pocasset Mill. From here, the river flows a few more hundred feet to the bay. As stated at the beginning of the chapter, these photographs were first printed in conjunction with a study done for the Watuppa Ponds and Quequechan River Commission in 1914–1915.

Five

Places of Worship

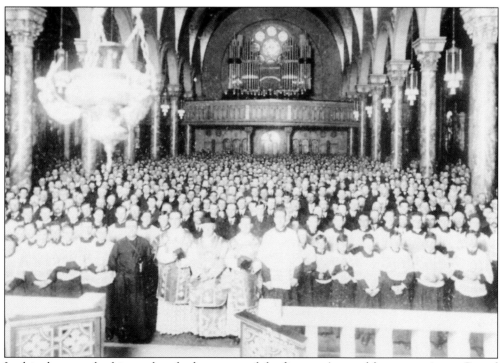

In this photograph, thirteen hundred men attend the first men's monthly communion at Sacred Heart Church, on March 21, 1917. (Courtesy of Father John C. Ozug.)

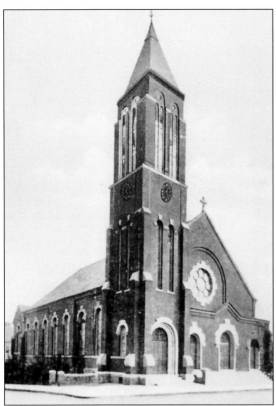

Pictured here is Sacred Heart Church, located at the corner of Linden and Pine Streets. In 1872 Saint Mary's parish was divided and Sacred Heart parish was born. The church cornerstone was dedicated in 1873, and the church was completed and dedicated in 1883. (Courtesy of Father John C. Ozug.)

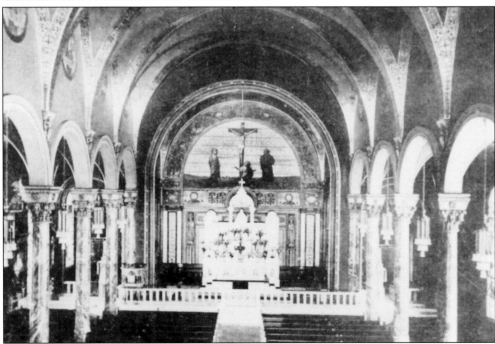

The interior view of Sacred Heart was taken from the choir loft. The communion rail seen in this photo has since been removed. (Courtesy of Father John C. Ozug.)

Sacred Heart Rectory, on the corner of Winter and Cherry Streets, was built for use as a Baptist presbytery. It was next used as the residence of Bishop Stang. In 1905 Doctor Truesdale opened his first hospital in the building, and in 1911 the pastor of Sacred Heart purchased it to be used as a rectory. (Courtesy of Father John C. Ozug.)

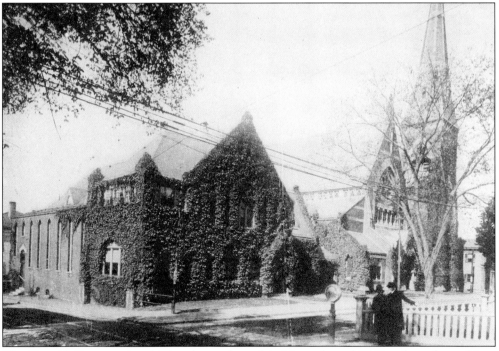

The Central Congregational Church was formed in November of 1842 and was housed in a wooden structure on the corner of Rock and Bedford Streets. In 1875 this church on Rock Street was erected, based on a design by Hartwell and Swazey of Boston.

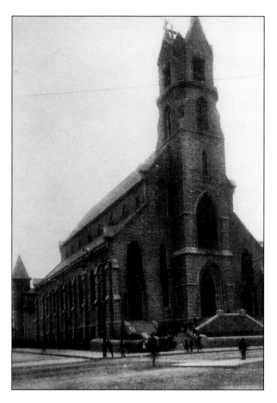

Saint Patrick's on South Main Street was founded in 1873 when Saint Mary's parish was again divided. The first church was a wooden structure built under the watchful eye of Father John Kelly, its first pastor. In September of 1881 the cornerstone was laid for the present church, pictured here, which was completed in 1889. Father Kelly's tomb lies beneath the church that he founded.

Reverend Doctor Hughes was pastor of Saint Mary's Cathedral from 1887 until 1908. Reverend Hughes took on the task of finishing the interior of the church. He had three altars installed, as well as new pews and a heating system, and had the stained-glass windows imported from Germany. (Courtesy of Mary V. O'Neil.)

Saint Mary's Cathedral, on Spring Street, was established in 1836 as Saint John the Baptist Church. The first church on this site was a small wooden chapel. In the 1840s, the Catholic population in the city grew rapidly and the rear of the chapel was enlarged into Fall River, Rhode Island. In 1852 the cornerstone for this building was laid. The cathedral was built in the Gothic style, using uncut granite. It was dedicated in 1855 as Saint Mary's Cathedral.

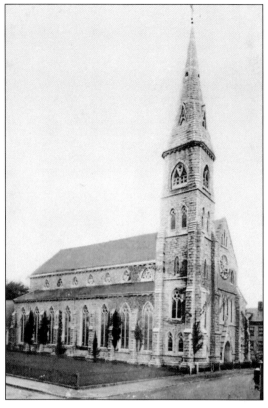

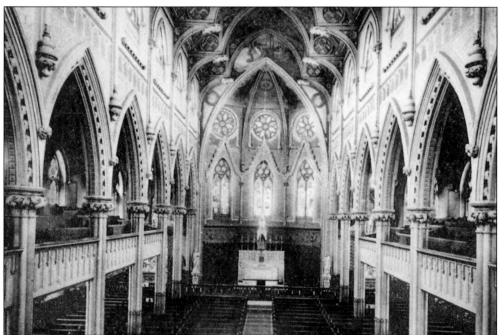

This is an interior view of Saint Mary's Cathedral. The improvements in the interior cost $130,000 in the 1890s, a debt that was paid off in less than fourteen years.

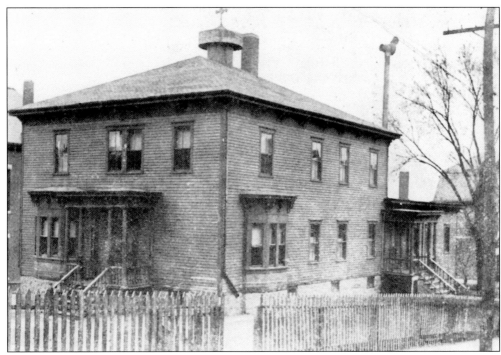

Shown here is Saint Anne's first parish house, located on the corner of Hunter and Hope Streets. During the early part of the century, it was an elementary school run by the Christian Brothers and then by sisters from 1909 until 1925. (Courtesy of the Dominican Sisters archive.)

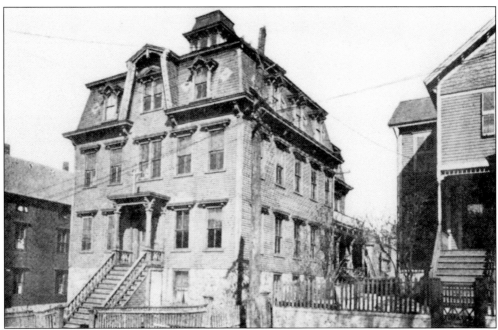

The Holy Cross Sisters lived here at Saint Anne's Convent on Grant Street from 1883 until 1895. From 1895 to 1909, it was the Christian Brothers' residence. (Courtesy of the Dominican Sisters archive.)

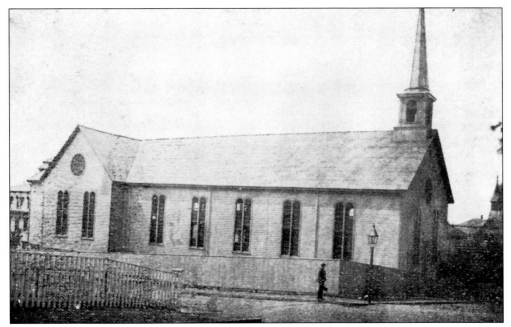

When it was formed in 1869, the first Saint Anne's Church on Hunter Street was the first French religious organization in Fall River. This church was built in 1870 and served the parish until the new church was dedicated. Until 1883, classes were held in the basement of the church. (Courtesy of the Dominican Sisters archive.)

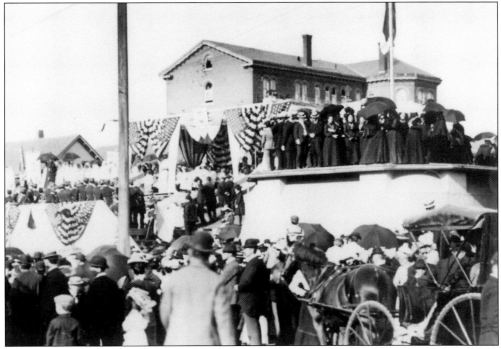

Pictured here is the blessing of the cornerstone of Saint Anne's Church on July 14, 1902. The rear of Saint Catherine's Convent, home of the Dominican Sisters, rises in the background. (Courtesy of the Dominican Sisters archive.)

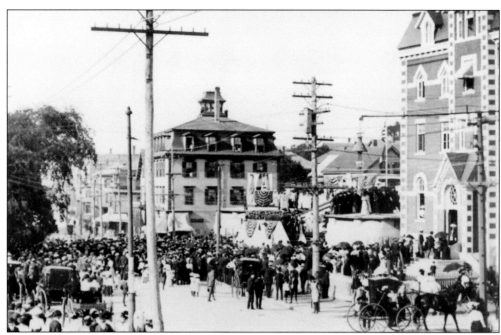

This is another view of the dedication, looking north down South Main Street. The building to the right is Saint Anne's Rectory. (Courtesy of the Dominican Sisters archive.)

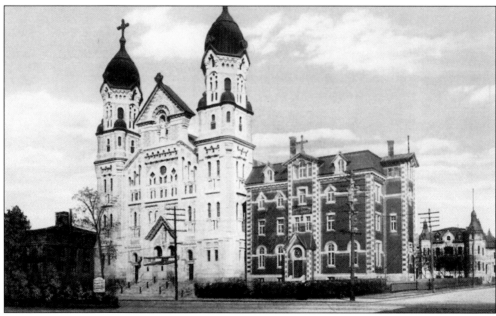

Saint Anne's Church was built in the Roman Byzantine style and was completed in 1906. The brick building on the corner of Middle and South Main Streets was the rectory until 1909, when the brothers moved to 818 Middle Street. In 1909 Saint Anne's Commercial College moved from Grant Street to this building, where it operated until 1926, when the school closed. (Courtesy of the Dominican Sisters archive.)

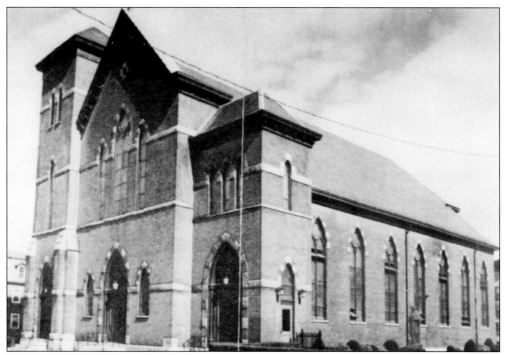

Saint Joseph's Church on North Main Street was founded in 1873, with Reverend William Bric as the first pastor. At first, a small wooden church was built, but in August of 1880, the cornerstone of this church was laid. The church was consecrated in May of 1885. Until 1877, Somerset was a mission of the parish. (Courtesy of the Dominican Sisters archive.)

The twin spires of Notre Dame Church were photographed across the Quequechan River in 1914. The church was established in 1874 as a division of Saint Anne's. The first church burned down in 1903. That same year, the church pictured was begun, and it was finished in 1906. On May 11, 1982, a fire consumed the church and over thirty-five buildings in this Flint neighborhood.

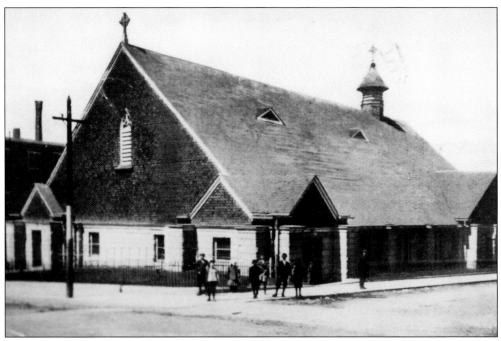

Santo Christo was founded in 1891 by Father Neves. This photo shows the first structure to house the Portuguese congregation. (Courtesy of the Fall River Public Library.)

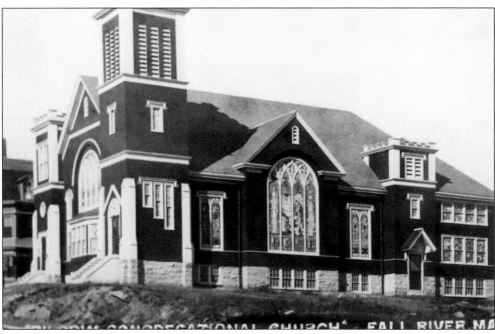

The Pilgrim Congregational Church was opened as a mission in January of 1893. The building pictured here was erected in 1910 on Center Street and was dedicated as the Broadway Congregational Church. (Courtesy of the Fall River Public Library.)

Six

Schools

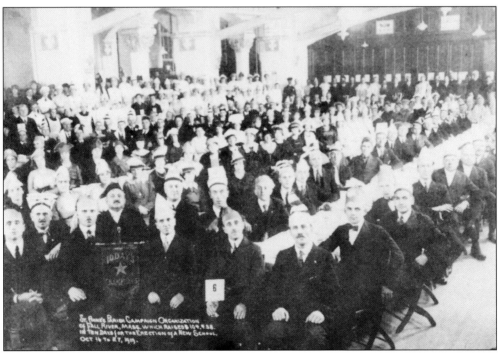

A supper was organized to raise funds for the construction of the new Saint Anne's School. During a ten-day campaign, October 16–27, 1919, the parish raised over $104,000 for the school building fund. (Courtesy of the Dominican Sisters archive.)

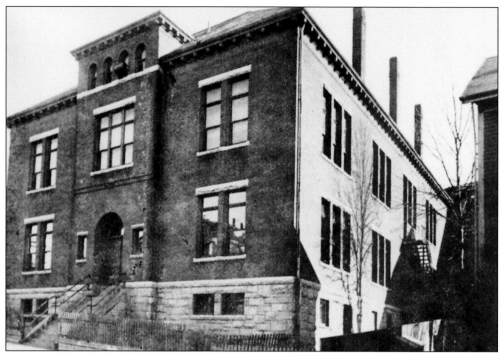

Pictured here is Saint Anne's School on Hope Street. By 1890 the city's parochial schools were overcrowded, and in 1891 the Dominican Fathers opened this new school, which served until 1925 when the Forrest Street school was opened. (Courtesy of the Dominican Sisters archive.)

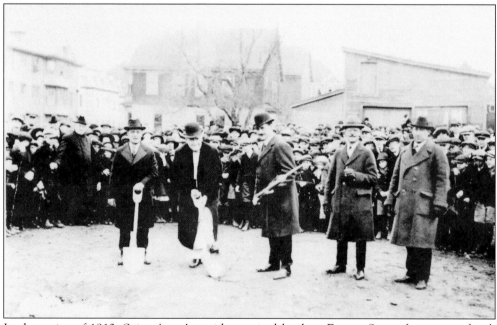

In the spring of 1912, Saint Anne's parish acquired land on Forrest Street for a new school. World War I interrupted the building plans, but in 1922 plans were finally drawn up and approved by Bishop Feehan. This photograph highlights the April 24, 1922 groundbreaking. (Courtesy of the Dominican Sisters archive.)

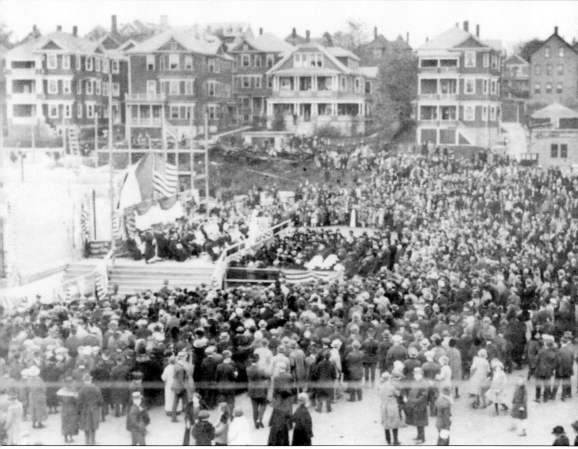

The dedication of Saint Anne's School on Forrest Street is shown in this October 21, 1923 photograph. Bishop Feehan is blessing the cornerstone of the school. Triple-decker apartment houses line Osborne Street in the background. (Courtesy of the Dominican Sisters archive.)

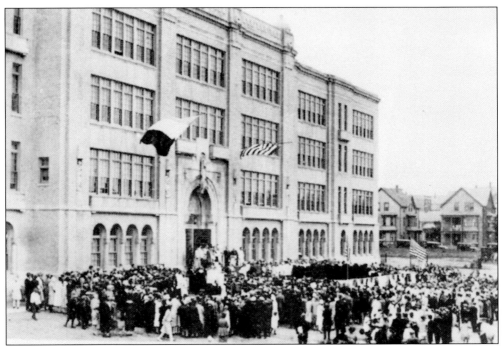

This photograph shows the dedication ceremonies for Saint Anne's School on September 13, 1925. Again, Bishop Feehan presided over the festivities. When the school opened, the three smaller parish schools, on Hunter, Grant, and Hope Streets, were closed. (Courtesy of the Dominican Sisters archive.)

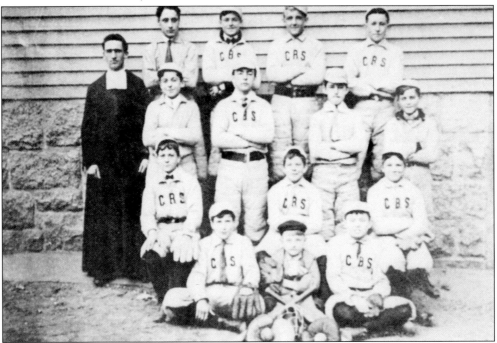

Brother Didier Gustave and the CBS baseball club are pictured here in 1908. The Hunter Street school serves as a backdrop. (Courtesy of the Dominican Sisters archive.)

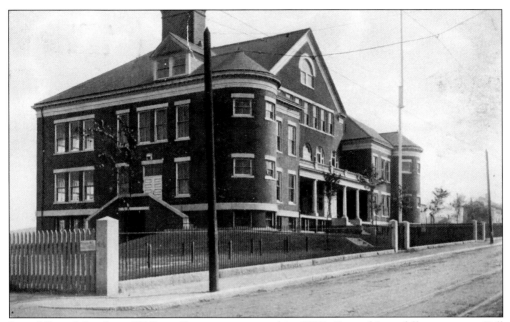

Longfellow School, on William Street, was opened in 1900. Samuel Longfellow came to Fall River in the mid-1800s as the pastor of the Unitarian Church, and at one time served as the chairman of the school committee. His brother was the poet, Henry Wadsworth Longfellow.

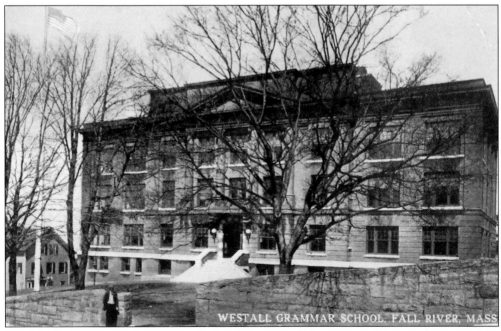

WESTALL GRAMMAR SCHOOL, FALL RIVER, MASS

The Maple Street school was named after John Westall in 1889, and it had the first public kindergarten in the city. In 1906 the school was condemned, and the new Westall Grammar School, pictured here, was opened in 1908.

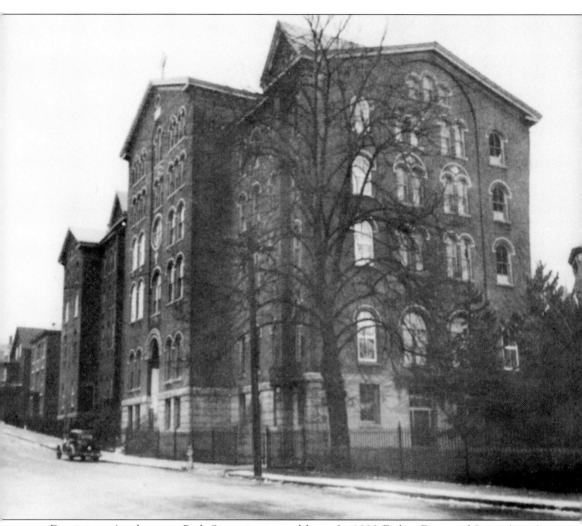

Dominican Academy on Park Street is pictured here. In 1890 Father Esteva of Saint Anne's invited the Dominican Sisters to Fall River. The sisters arrived in 1891 and immediately began to teach. This building was erected in 1895 and enlarged twice, once in 1908 and again in 1916. (Courtesy of the Dominican Sisters archive.)

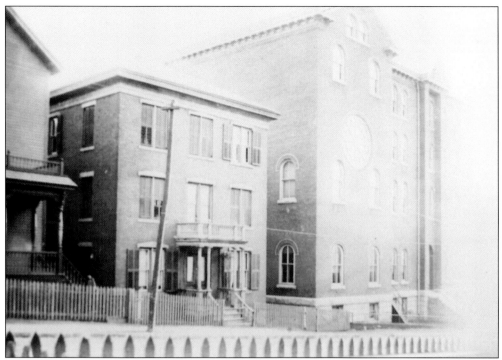

This small brick building was located at 37 Park Street and was part of the original convent. It has since been torn down to make room for parking. The structure to the left is Dominic Hall, which was purchased in 1949 and then connected to the school. (Courtesy of the Dominican Sisters archive.)

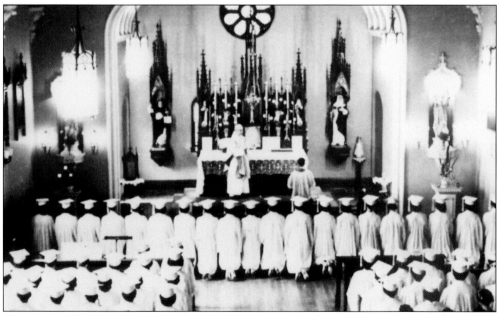

The original Gothic Altar in the chapel of Dominican Academy is pictured in this photograph from 1950s. (Courtesy of the Dominican Sisters archive.)

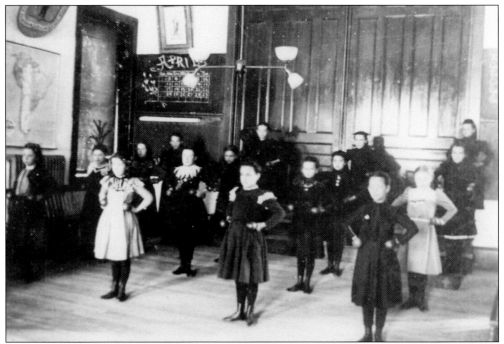

Pictured here is a 1920s class at Dominican Academy doing calisthenics. The girls are, from left to right: (first row) Mollie O'Connor, Agnes Brady, Alma Bourget, and Mamie Whiler; (second row) Valerie Lacoursiere, Margaret Sullivan, Robertine Legendre, and Nellie Corrigan; (third row) Marie Anna Methe, Eugenie Belanger, Lucie Adam, and Marion Cardin; (back row) Laura Rousell, Theophile Trottier, Mary Solca, and Dina Legendre. (Courtesy of the Dominican Sisters archive.)

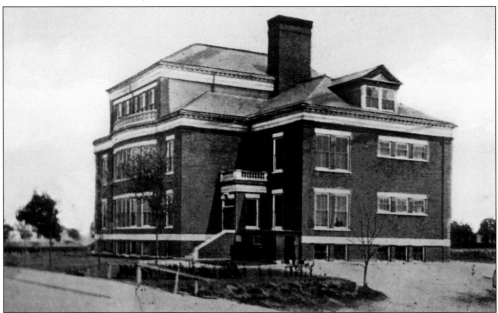

The Highland School on Robeson Street opened in 1901, and the school's first principal was Orrin A. Gardes.

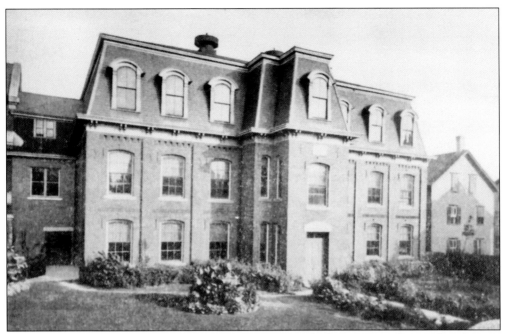

The original Sacred Heart School, on Seabury Street, was built in 1886 and opened its doors to the first students in 1887. In 1952 a new building was erected on the site to provide a convent for the sisters. For the last few years, the parish rectory has been housed in the building. (Courtesy of Father Ozug.)

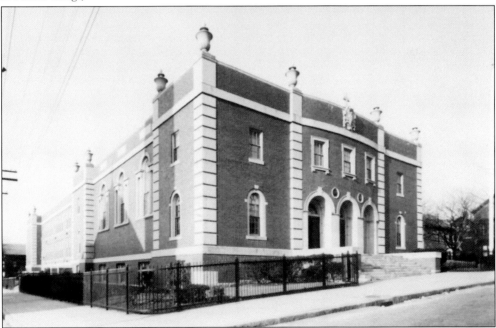

In 1932 Father Edward Carr erected Sacred Heart School on Linden Street, across from the church. The school could accommodate over seven hundred students in grades kindergarten through eight. The school remained open until 1977, and later the building was remodeled to house apartments. (Courtesy of Father Ozug.)

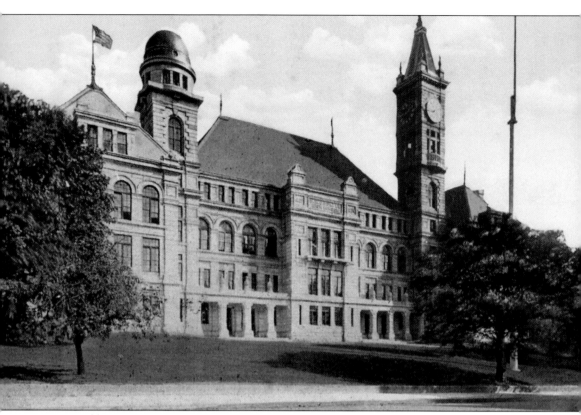

Pictured here is B.M.C. Durfee High School on Rock Street. In 1882 Mrs. Mary Durfee Young offered to build and outfit a high school to be dedicated in honor of her son, Bradford Matthew Charloner Durfee, who had died in his 1920s. The school opened in 1886 and cost $1 million. It housed an observatory for the study of astronomy as well as a handsome clock tower. The building served as a high school until 1977, when a new campus was built on Elsbree Street. Today, the school has been renovated to house the Fall River Trial Court.

This is a birds-eye view from the observatory of B.M.C. Durfee High School looking southwest.

Pictured here is a view taken from the high school looking west toward the waterfront.

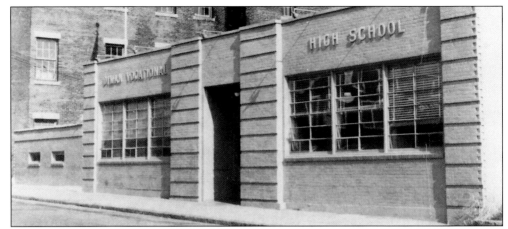

Shown here is Diman Vocational High School on Hartwell Street. At a school committee meeting in August of 1912, Reverend John Diman, founder of Saint George's School in Middletown, Rhode Island, and the Portsmouth Abbey, offered $2,000 to set up a manual training center in Fall River. Rev. Diman continued his financial support until the City assumed the obligation in 1915. (Courtesy of John P. Harrington.)

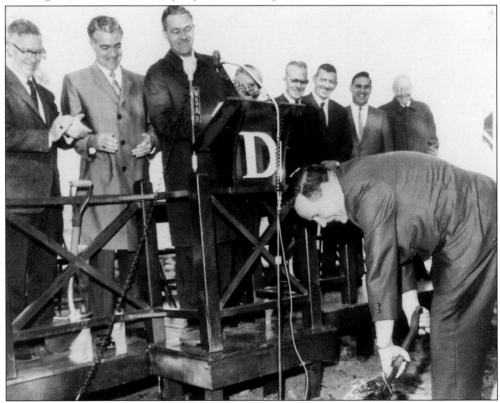

In 1963 John Harrington, in starting the initial planning for the school's new campus, pursued the regionalization of several area vocational school districts, including Fall River, Somerset, Swansea, and Westport. In this photo, Mr. Harrington breaks ground for the new school while L. Quinn, Mayor Desmarais, E. Wheeler, M. Salmond, F. Harrington, C. Latham, R. Harmon, and R. Acheson (from left to right) look on. (Courtesy of John P. Harrington.)

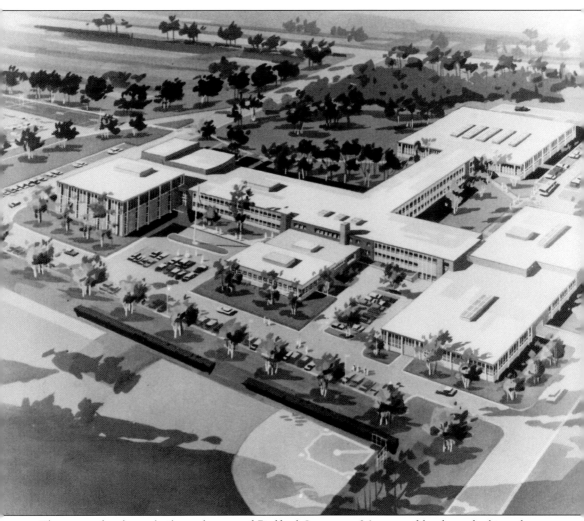

The new school was built at the top of Bedford Street on 36 acres of land overlooking the North Watuppa Pond. The physical layout of the school is over 300,000 square feet in area, including an auditorium with capacity for over six hundred and fifty seats, and a gymnasium with a capacity of over one thousand. The John P. Harrington Athletic Field boasts a six-lane quarter mile track and football, soccer, and baseball fields. (Courtesy of Dennis A. Abdow.)

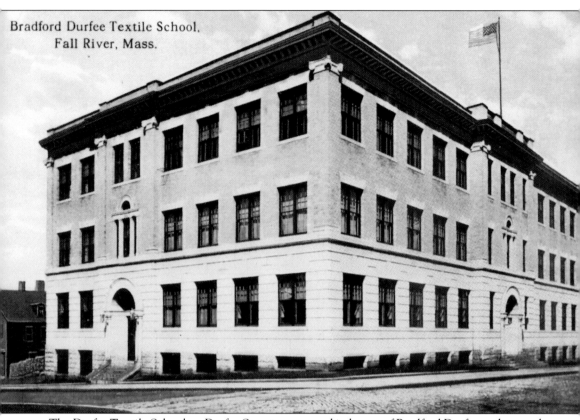

Bradford Durfee Textile School,
Fall River, Mass.

The Durfee Textile School on Durfee Street was named in honor of Bradford Durfee and opened in 1904, on land that had been part of the Bradford Durfee estate. In the 1960s it merged with the New Bedford Institute of Technology to form Southeastern Massachusetts Technical Institute .

Seven

Neighborhoods
and People

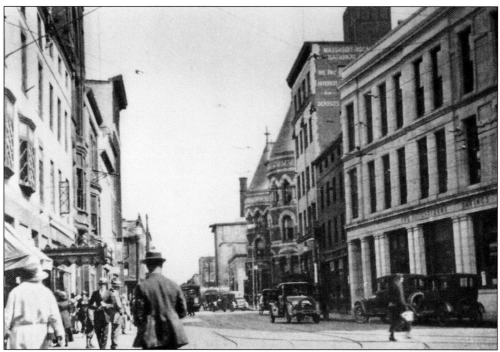

This view, looking east from the corner of North Main Street, shows Bedford Street before the 1928 fire. Bedford Street was first known as Central Street, and the Central Street of today was known as Proprietors Way. (Courtesy of the Dominican Sisters archive.)

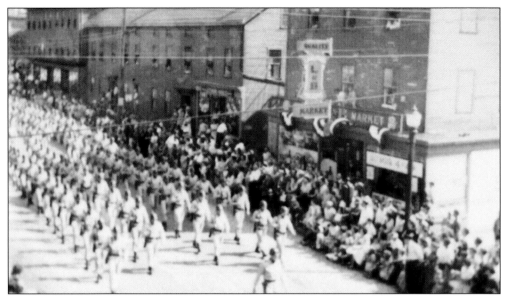

A parade travels down Bedford Street in 1954, as part of the city's centennial celebration. The three buildings visible are between Ninth Street and Eighth Street. The L & B Market is to the right. The building in the middle housed a warehouse for the market, and the upper stories held apartments. The only structure to survive is the third building, with the mansard roof. (Courtesy of Ed and Mary Depin.)

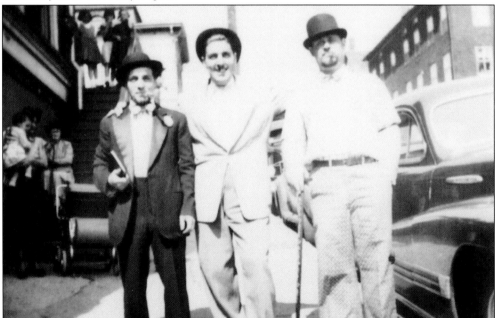

Fall River was incorporated as a city in 1854. To celebrate the centennial in 1954, a week-long celebration was planned. The Brothers of the Brush, pictured here, raised money for charities that week. If a man didn't grow a beard or dress in funny clothes, he would be "jailed," and the fine would be donated to charity. In this photograph, Eddy Lewis, Larry Benevides, and Ed Depin (from left to right) pose on the corner of Bedford and O'Grady Streets. (Courtesy of Ed Depin.)

Yvonne Depin Melanson poses for the camera in 1950. Behind her is the Bedford Furniture Company, located on Bedford Street at Ford Street. (Courtesy of Donna Fitzgerald.)

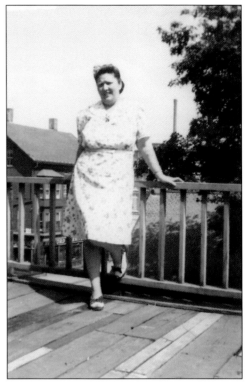

Rob Lewis is pictured in a carriage with his mother, Irene Depin Lewis, standing beside him in this 1954 photograph. The Globe Manufacturing Company is visible in the background. (Courtesy of Donna Fitzgerald.)

Pictured here are Dot Barboza and her son Eddy in the late 1940s. They are standing on Ninth Street, near the corner of Bedford Street. The building in the background was the Bedford Street school, which opened in 1871 and closed in 1900. During the 1930s the building served as the office for a lumberyard on the site. (Courtesy of Ed and Mary Depin.)

This photograph shows Pleasant Street between Eighth and Ninth Street, around the turn of the century. The tall white building was the home to Buffalo Bill's junk store in the 1960s. (Courtesy of the Dominican Sisters archive.)

Enrico Henry Marzilli is pictured here in 1918. The young boy is Frank Fasko, and the horse was named Prince. (Courtesy of Marzilli's Bakery.)

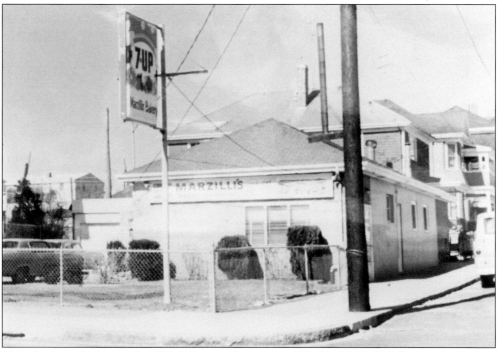

This photograph shows Marzilli's Bakery at the corner of Bedford and Wall Streets. In the late 1980s, an addition was built that extended the store to Bedford Street. It replaced an addition that was blown down during the 1938 hurricane. (Courtesy of Marzilli's Bakery.)

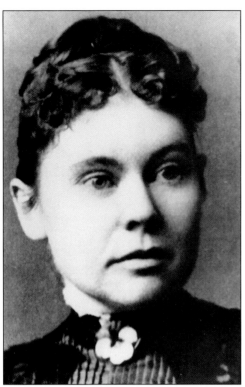

Lizzie Andrew Borden (1860–1927), alleged ax murderess, is Fall River's most well-known citizen. She was accused of the August 4, 1892 murders of her father and step-mother. (Courtesy of the Fall River Public Library.)

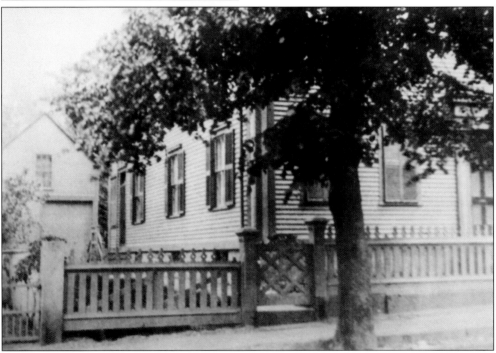

This photograph of the Andrew Borden house on Second Street was taken shortly after the murders. The barn that was referred to in the trial can be seen to the left. (Courtesy of the Fall River Public Library.)

On August 12, 1892, eight days after the murders, Lizzie was arrested and booked in the Fall River Police Station. The photograph of the original arrest book shows her arrest highlighted. During her trial, she was incarcerated in the Taunton County Jail. (Courtesy of the Fall River Police Department.)

This photograph shows the gatehouse and main entrance gates to Oak Grove Cemetery. In 1855 the City acquired almost 50 acres of land to be used as a cemetery. Of the many notable graves in the cemetery, the most famous is the resting place of Lizzie Borden.

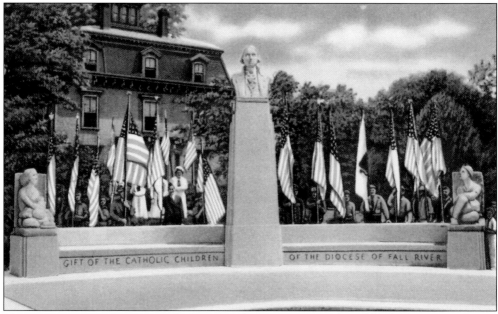

The monument to George Washington at the intersection of Highland Avenue and New Boston Road was a gift from the Catholic schoolchildren to the city in 1945. The house in the background was built in the 1880s and belonged to E.S. Brown, owner of the E.S. Brown Department store (see page 11).

Pictured here is Ruggles Park around 1900. In the 1600s the park was the site of a permanent Native American settlement, in part because of a natural spring that flowed through the area. In 1868, twelve acres of the Rodman farm was purchased by the City. At first it was known as Ruggles Grove, but in June of 1895, it was dedicated as Ruggles Park.

In 1829 Rock Street was laid out through John C. Borden's land. At first it was known as Exchange Street, but by 1835, it was given the name Rock Street.

This view shows North Park, at the bottom of Hood Street. Originally part of the city farm, the land was set aside as a park in 1883. It wasn't until 1904 that the 12-acre site was landscaped.

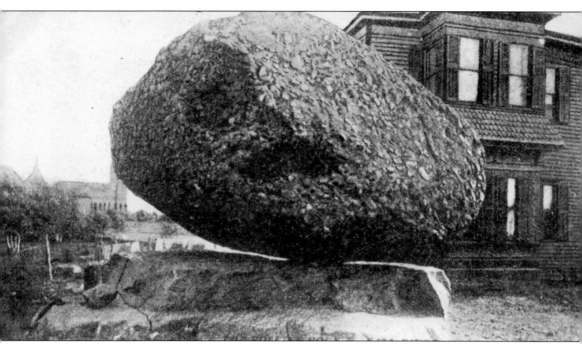

The Rolling Rock, at the intersection of Eastern Avenue and County Street, is estimated to weigh over 140 tons and could be moved with the push of a hand, until being stabilized in the 1930s. In the 1870s the section of the city known as the Flint saw rapid growth. Until this time, the area was mostly farmland, but in the 1870s the land developed into a village of the city.

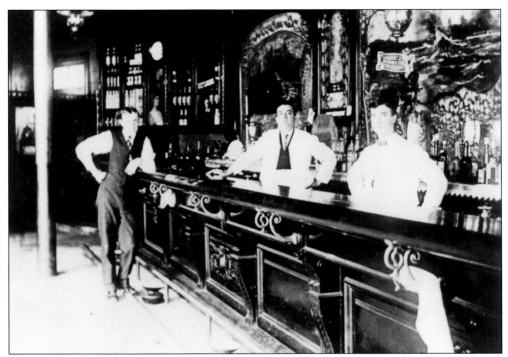

This barroom was located at the corner of Quequechan Street and Pleasant Street. The photograph dates to 1910. Notice the spittoon on the floor. (Courtesy of Jim McKenna.)

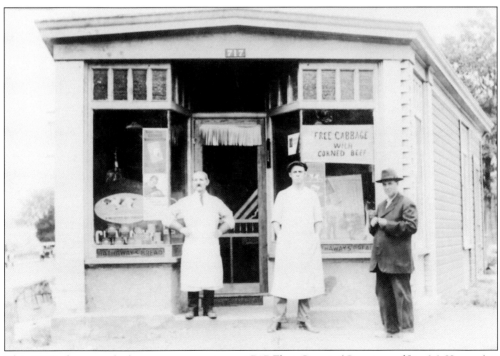

This 1910 photograph shows a grocery store at 717 Flint Street. (Courtesy of Jim McKenna.)

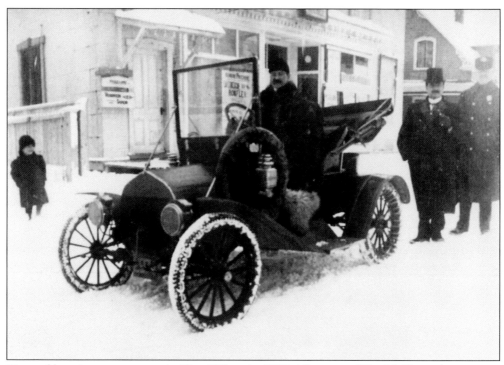

Pictured here is a snowy scene in Flint Village in 1910. (Courtesy of Jim McKenna.)

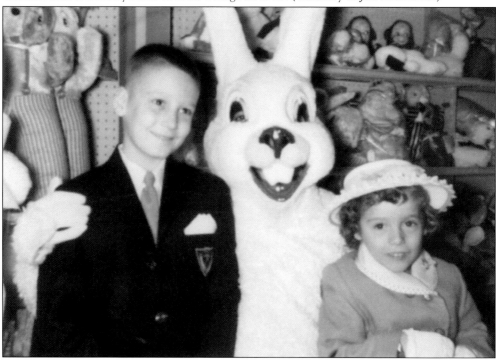

Rob Lewis, the Easter Bunny, and Donna Marie Lewis pose for the camera in 1963. A visit to the Easter Bunny at the Pleasant Drug store was a tradition for many who grew up in Fall River. (Courtesy of Donna Lewis Fitzgerald.)

The Savoy Theater at 28 North Main Street is pictured here around 1911. Next door to the theater was Charlie Wong's Restaurant.

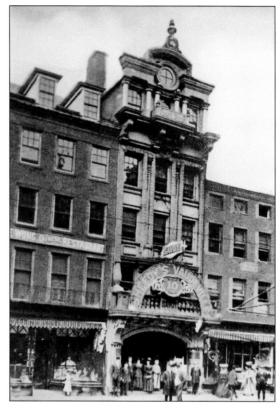

This postcard reads, "King Philips Well near Fall River." This natural spring-fed stream was located on Mount Hope in the area that now comprises Roger Williams University. (Courtesy of Fall River Public Library.)

The pavilion at South Park is shown here. In 1868, sixty acres of the Durfee farm was purchased by the City for eventual use as a park. In 1871 Frederick Law Olmsted, of Vaux and Olmsted, was commissioned to lay out the new park . In the mid-1960s the name was changed to Kennedy Park, after the assassination of John F. Kennedy.

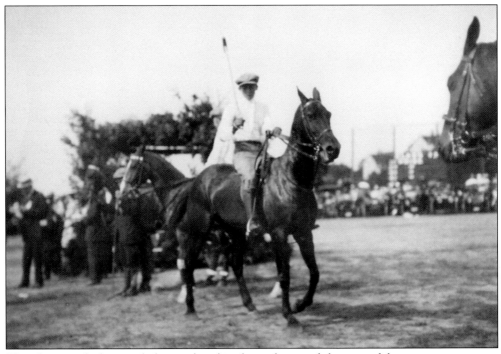

This photograph shows polo being played in the park around the turn of the century.

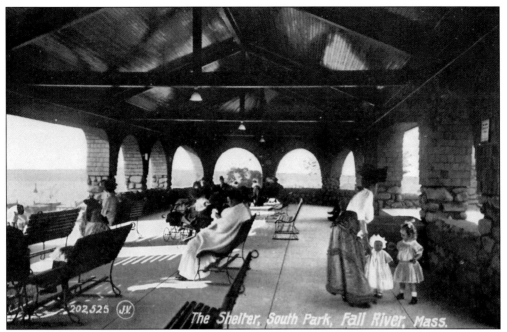

The Shelter, South Park, Fall River, Mass.

Pictured here is the shelter on the Esplanade at South Park. Unfortunately, a fire in the 1970s destroyed the wooden part of the structure. Kennedy Park is the city's largest park, and the view from the top of the park is outstanding.

Theresa Leonard Donegan, to the left, and a friend are pictured in this photograph from around 1905. (Courtesy of Mary V. O'Neil.)

These people are dressed for the Orphan's Picnic on July 4, 1919. Over fifteen thousand people turned out for the event that benefited Saint Vincent's Home. In this photograph are, from left to right: Mrs. O'Neil, Lizzie Kelley, Mrs. Lawlor, Kate McGann, Charles O'Neil, and the Beattie girl. (Courtesy of Mary V. O'Neil.)

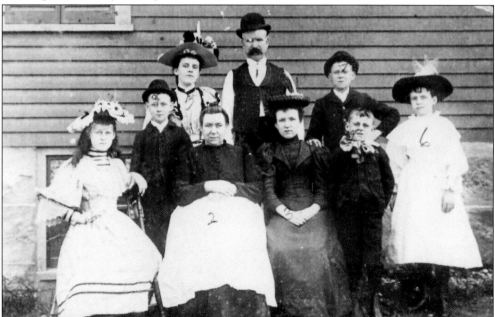

The Leonard family are shown in this photograph from around 1878. They are, from left to right: Theresa, Peter, Anne, Mary (mother), Patrick (father), Mary V., Matthew, Thomas, and Winifred. Patrick and Mary Leonard came to the United States in 1870. At first, Patrick worked as a gardener on President Adam's estate in Quincy, and later, after moving to Fall River, he made shoes for a living. (Courtesy of Mary V. O'Neil.)

Eight

Great Conflagrations

This photograph shows Engine #3 from New Bedford at about 1 am on February 3, 1928. In the early days of Fall River, there was little chance of extinguishing a fire once it started. In the mid-1800s, as houses were built closer together, a system of cisterns was built around town to supply water in the event of a fire. By the mid-1870s, with the introduction of the city water system, hydrants began to spring up everywhere.

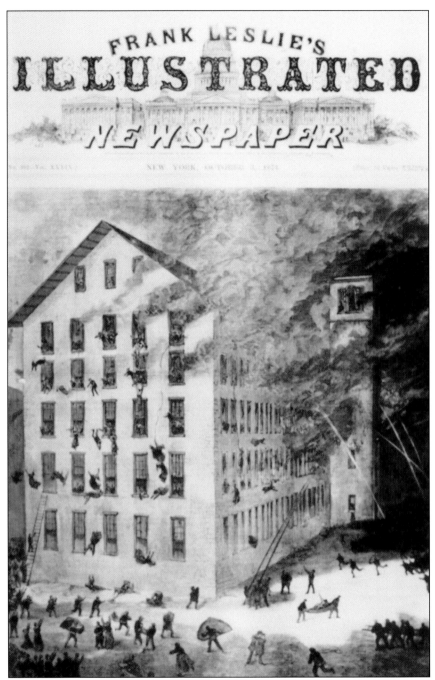

This is a newspaper illustration of the Granite Mill fire of September 19, 1874. Newspapers reported it as "the most calamitous conflagration to ever befall the city." The mill, which was located on Twelfth Street, between Bedford and Pleasant Streets, burned to the ground, taking twenty-three operatives to their graves and injuring many more. The subsequent investigation forever changed the way mills were constructed, and led to the addition of external fire escapes and sprinkler systems. The China Royal Restaurant stands on this site today. (Courtesy of Jim McKenna.)

This is a view of South Main Street looking south, before the 1916 fire. The Steiger Company (first on the right) and Cherry and Webb are seen in the photograph. (Courtesy of Ed Depin.)

South Main Street is shown here, looking north, the morning after the 1916 fire. The fire started in the basement of the Steiger store late in the evening of February 15, 1916. Over thirty businesses were destroyed, and the losses totaled over $1.5 million. (Courtesy of Fall River Fire Department.)

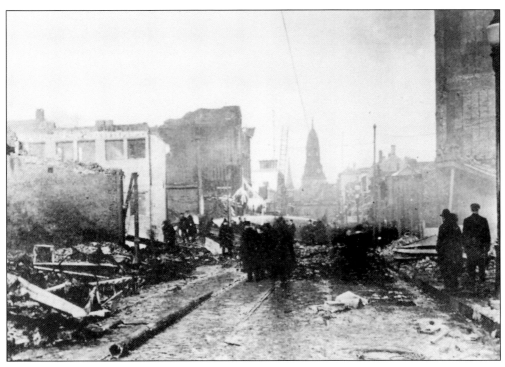

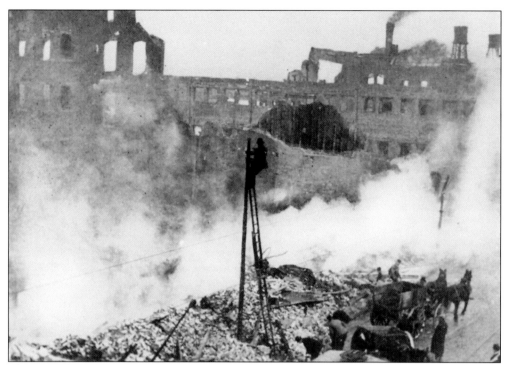

This is another photograph taken after the 1916 fire, looking north along Main Street. The fire burned for over five hours and consumed several acres of the business district.

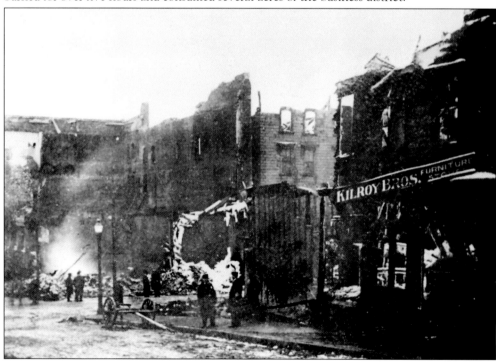

The is a view from Saint Mary's Cathedral looking at what was once the Campbell Building, located at 231 South Main Street, c. 1916.

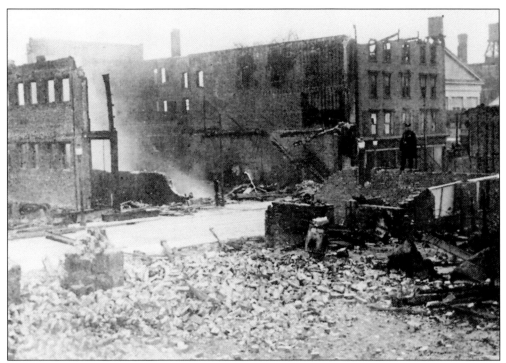

This c. 1916 view shows the ruins of the Campbell Building and the surrounding debris. (Courtesy of Fall River Fire Department.)

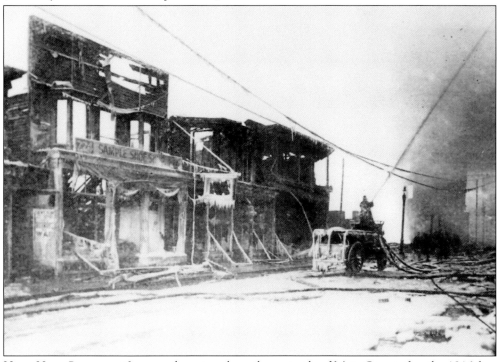

Here, Hose Company #3 sprays the ruins along the east side of Main Street after the 1916 fire. (Courtesy of Fall River Fire Department.)

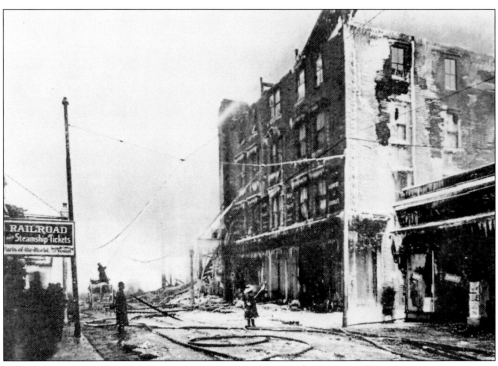

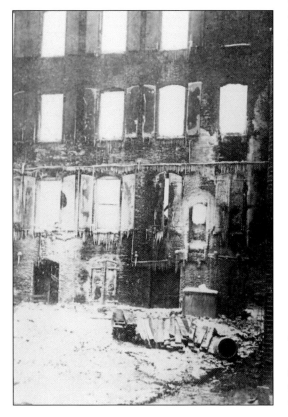

Cobb, Bates, and Yerxa, grocers, at 221 South Main Street was where the 1916 fire was stopped to the north of Steiger's store. (Courtesy of Fall River Fire Department.)

This is the rear of Cherry and Webb in the Exchange Building. Had the fire shutters been closed, the wall may have checked the fire at this point. (Courtesy of Fall River Fire Department.)

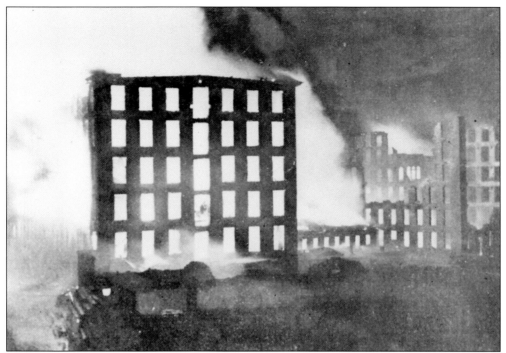

The Pocassett Mill is engulfed by flames on February 2, 1928. At about 5:30 pm, a fire started in the Pocassett Mill complex. Within an hour it had destroyed the mill and the adjacent Granite Block. (Courtesy of Deb Collins.)

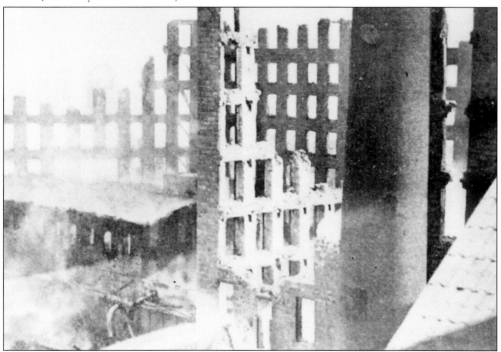

The empty shell of the Pocassett Mill is seen here the morning after the 1928 fire. (Courtesy of Fall River Fire Department.)

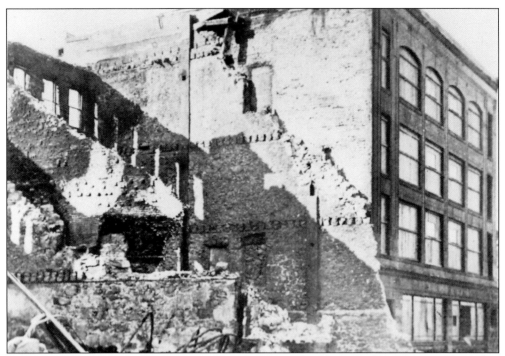

The ruins of the old Herald Building are pictured here after the 1928 fire. The *Herald* was first published in 1872 as the *Border City Herald*. In 1876 the paper changed hands and became known as the *Fall River Daily Herald*. The building standing in the background is home to the paper today. (Courtesy of Fall River Fire Department.)

These are the ruins of the Granite Block after the 1928 fire. The elevator shaft is to the left of the picture. (Courtesy of the Dominican Sisters archive.)

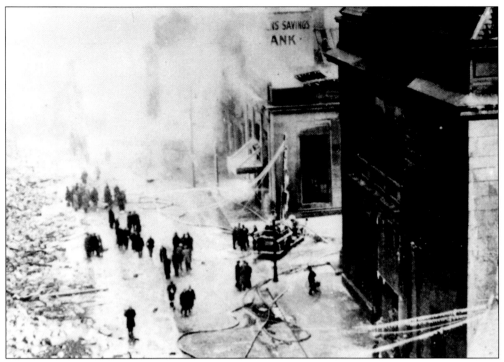

City Hall Square is pictured here during the 1928 fire. The Granite Block lies in ruins to the left while the city hall survives to the right.

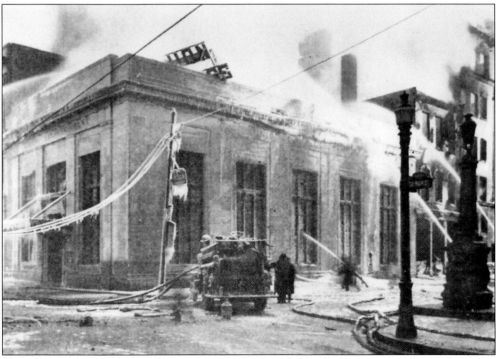

This photograph shows the Union Savings Bank and the Citizens Savings Bank about two hours before they were consumed by the 1928 fire. (Courtesy of Fall River Fire Department.)

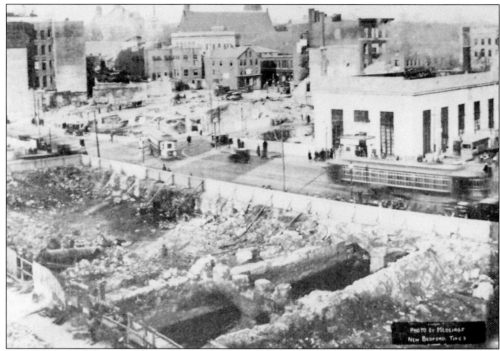

This is the site of the Granite Block after the 1928 conflagration. The Quequechan River flows beneath the roadbed and pylons.

This vault survived the 1928 inferno. In all, four banks were lost to the 1928 fire.

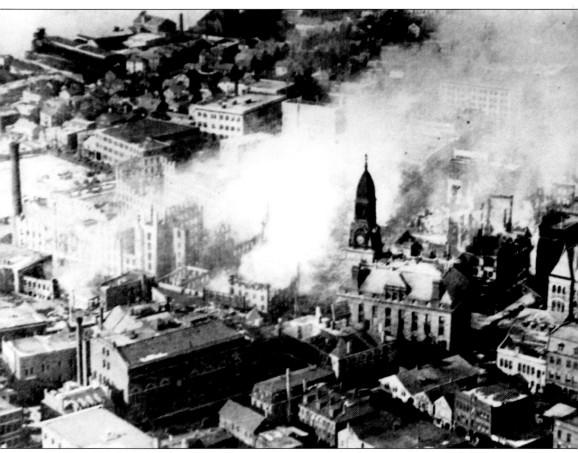

This is an aerial view of downtown the morning after the 1928 fire. The damage estimate was well over $30 million. It was through the brave effort of the Fall River Fire Department that the city hall and post office escaped the destruction. (Courtesy of Deb Collins.)

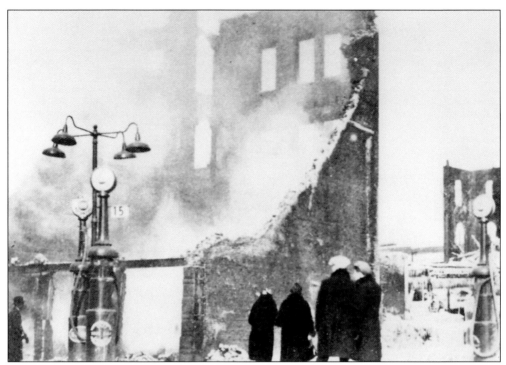

This is the corner of Granite and Purchase Streets after the 1928 fire. The gas pump shows a price of 15¢ per gallon. (Courtesy of Deb Collins.)

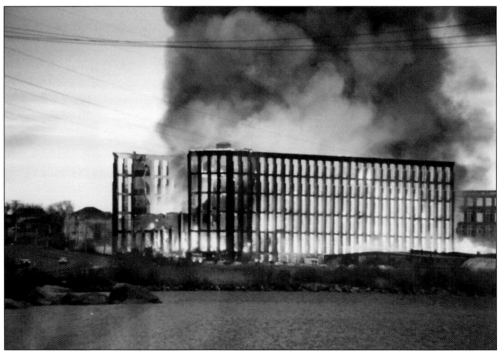

In this photograph, the Kerr Mill is seen burning to the ground (see page 34). (Courtesy of Scott Rounesville.)

Nine

The Fall River Line

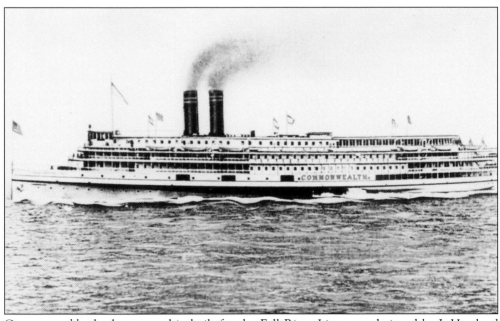

Commonwealth, the last steamship built for the Fall River Line, was designed by J. Howland of Newport and was built in Philadelphia. She was completed in 1908 and served until 1937, when the line went out of business. (Courtesy of the Marine Museum.)

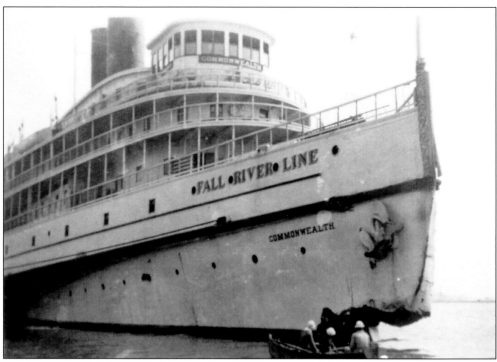

Here, the *Commonwealth* is being inspected after a minor collision. However, the ship was very safe and enjoyed an uneventful career. (Courtesy of the Marine Museum.)

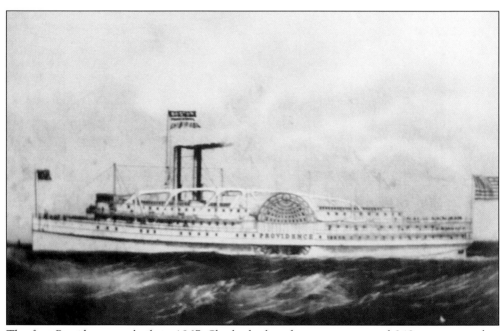

The first *Providence* was built in 1867. She had a hog frame structure and 240 staterooms that could accommodate over eight hundred passengers. The *Providence* served until 1894, when the *Priscilla* replaced her. She was sold for scrap in 1902. (Courtesy of the Marine Museum.)

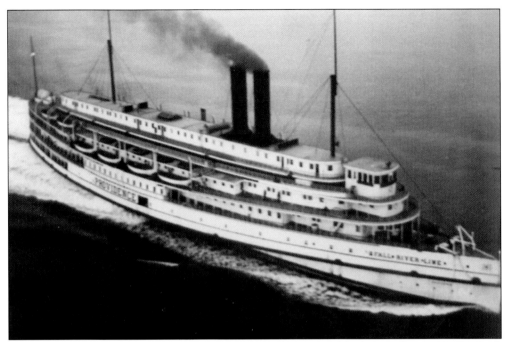

The second *Providence* was 397 feet long and was built in 1905. The boat had a steel hull, which let her builders abandon the hog frame structure of her earlier namesake. (Courtesy of the Marine Museum.)

This is a galley staircase from the second *Providence*. The interior of the ship was designed in the French Louis XVI style. (Courtesy of the Marine Museum.)

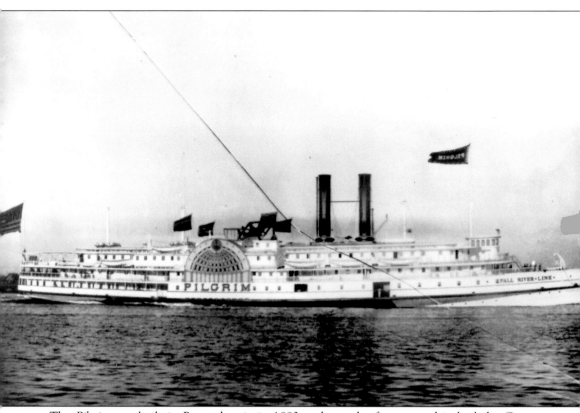

The *Pilgrim* was built in Pennsylvania in 1883 and was the first steamship built by George Pierce. She was 390 feet long and could hold twelve hundred passengers. The ship was the first Fall River Line steamer to be illuminated by electricity. The *Pilgrim* remained in active service until 1913 and was then scrapped in 1920. (Courtesy of the Marine Museum.)

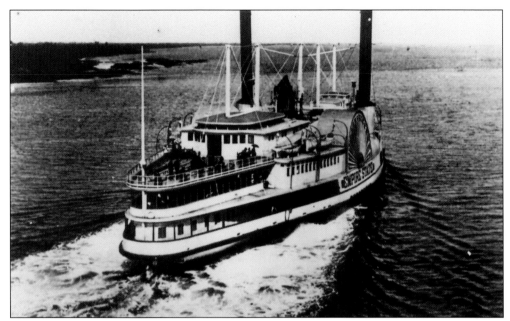

The *Empire State* was built in New York by Samuel Sneedon and was launched on March 18, 1848. On January 13, 1849, she was badly damaged by fire at her Fall River berth. The ship was rebuilt and back in service by June 1849. The *Empire State* remained with the Fall River Line until 1871. She was scrapped in Bristol in May 1887. (Courtesy of the Marine Museum.)

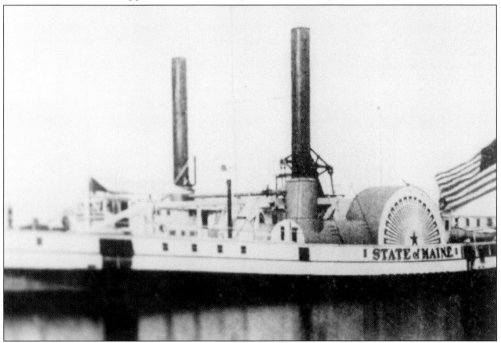

The *State of Maine* was built in 1848 and went into service in March 1849. The ship carried her two large copper boilers on her side guards, as seen in this photograph. She was used by the Fall River Line until 1863, when she was chartered by the government to serve as a hospital ship on the James River. (Courtesy of the Marine Museum.)

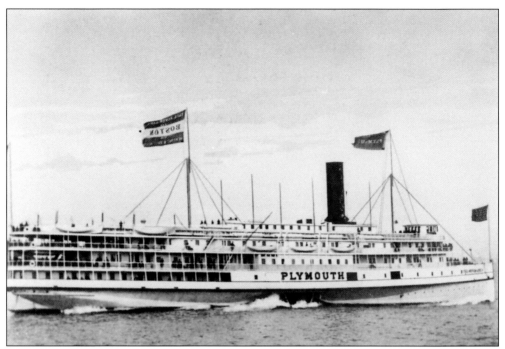

The *Plymouth* was built in 1890 as a secondary ship to fill in during the winter months. She was with the Fall River Line until it went out of business in 1937. This photograph shows the short flagstaffs that she carried before the 1906 fire. (Courtesy of the Marine Museum.)

On March 27, 1906, while docked in Newport, the *Plymouth* caught fire and her entire superstructure was destroyed. This photograph of the ship was taken the next morning. (Courtesy of the Marine Museum.)

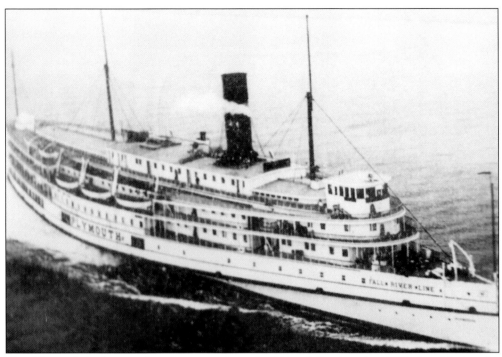

The *Plymouth* is shown after the extensive rebuilding following the 1906 fire. Notice the absence of the short flagpoles and the changes to the pilothouse. (Photograph by Ralph Arnold, Sr., courtesy of the Marine Museum.)

This photograph, looking aft from the forward stairway, shows a passageway on the *Plymouth*. (Courtesy of the Marine Museum.)

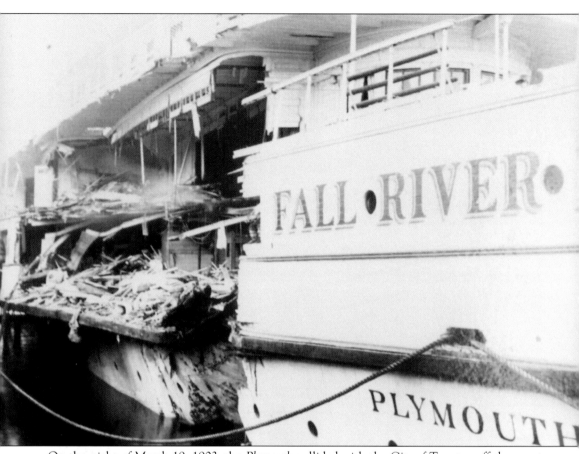

On the night of March 19, 1903, the *Plymouth* collided with the *City of Taunton* off the coast of Plum Island. The *City of Taunton's* bow was crushed, and the *Plymouth's* starboard side sustained a large gash. Both ships maintained their seaworthiness and were able to make it back to port. During the mishap, a passenger and two crew members were killed and several others were seriously injured. Both ships were repaired and put back into service. (Courtesy of the Marine Museum.)

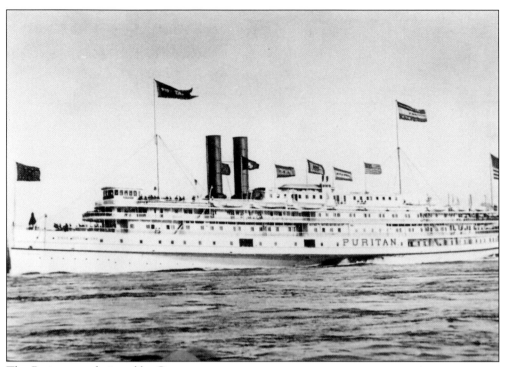

The *Puritan* was designed by George Pierce. She was launched in July 1888, and then went into service June 17, 1889. At 420 feet, she was the second largest steamship built by Pierce, and was probably his finest. (Courtesy of the Marine Museum.)

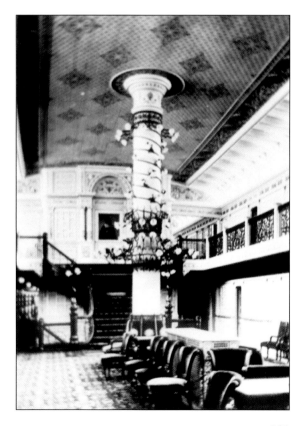

This is a photograph of the *Puritan*'s Grand Salon. (Courtesy of the Marine Museum.)

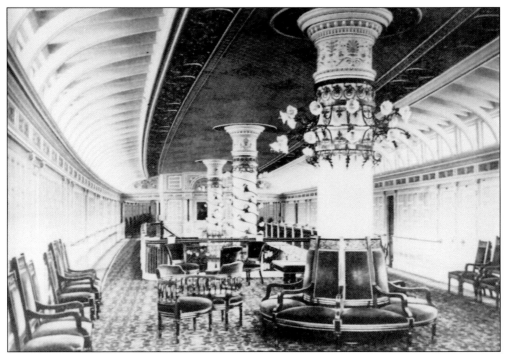

This view of the luxurious Gallery Saloon was taken aft from inside the *Puritan*. (Courtesy of the Marine Museum.)

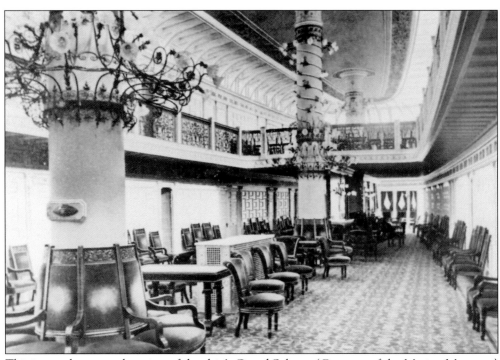

This image shows another view of the ship's Grand Saloon. (Courtesy of the Marine Museum.)

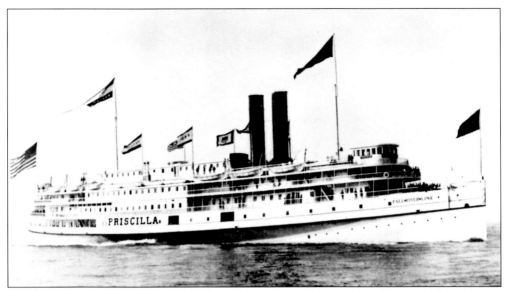

The Fall River Line steamship *Priscilla* is shown here while under full steam. The ship was launched in 1893 and could accommodate fifteen hundred passengers. She was 440 feet long, and her top speed was 22 miles per hour. The *Priscilla* was the largest ship designed by George Pierce. (Courtesy of the Marine Museum.)

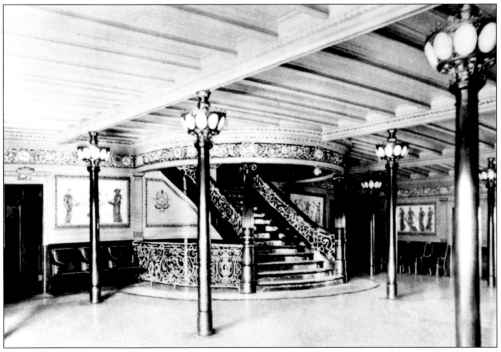

This is a view of the quarter-deck of the *Priscilla*. (Courtesy of the Marine Museum.)

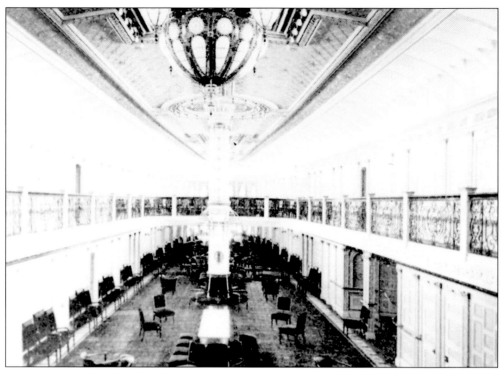

This is a view, looking aft, of *Priscilla*'s Grand Salon. (Courtesy of the Marine Museum.)

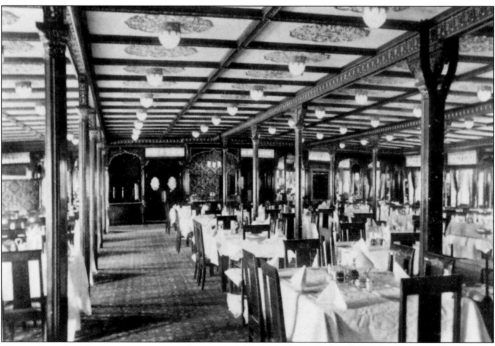

Generally, the dining room on a ship was placed below decks, but on the *Priscilla*, it was positioned on the main deck. The room was built of mahogany in an oriental style. (Courtesy of the Marine Museum.)

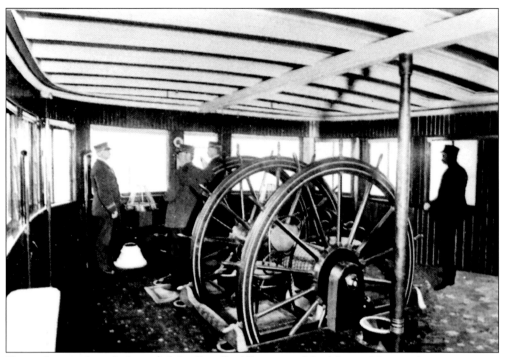

Shown here is the pilothouse of the *Priscilla*. (Courtesy of the Marine Museum.)

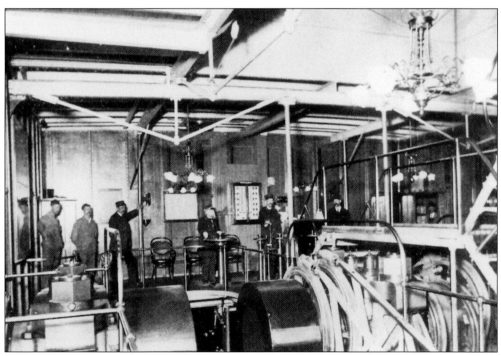

The engine room of the *Priscilla* came complete with chandeliers. The ship was originally outfitted with ten Scotch boilers, but in 1923 they were removed in Newport and replaced with eight water-tube boilers. (Courtesy of the Marine Museum.)

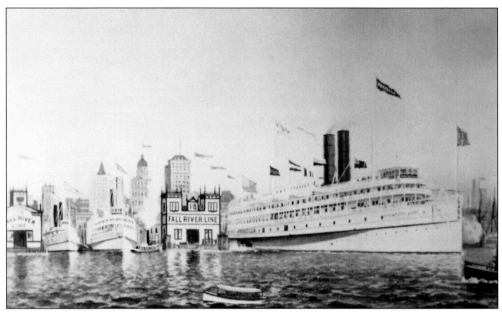

Here, the *Priscilla* leaves her New York pier. At the time of her launch, she was the largest sidewheel boat in the world, with her crew alone numbering over two hundred. (Courtesy of the Marine Museum.)

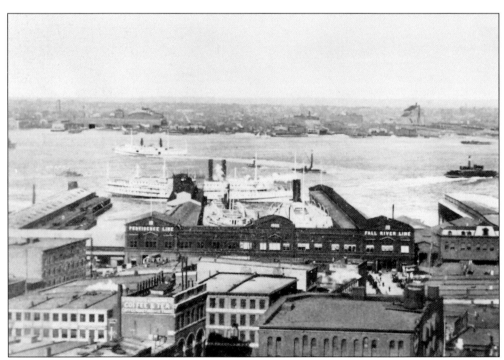

This is another picture of the Fall River Line terminal located in New York. (Courtesy of the Marine Museum.)

Shown here is the future home of the Marine Museum. This photograph shows the appearance of the building in 1968, when it was purchased. (Courtesy of the Marine Museum.)

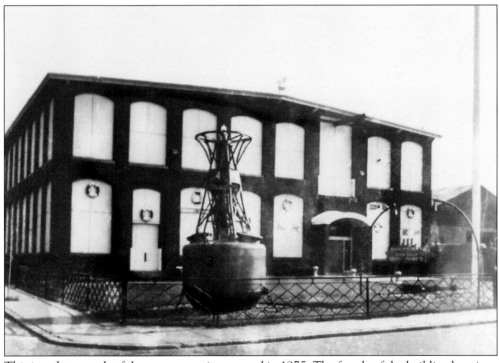

This is a photograph of the museum as it appeared in 1975. The facade of the building has since been remodeled. (Courtesy of the Marine Museum.)

Acknowledgments

The footwork and research for the Fall River book took over two years to gather. At first it was a side project while working on Newport and then Aquidneck Island. In the summer of 1996 Fall River became my focused attention. Many individuals and groups helped to make this volume come together as a glimpse into the city's past, through photography.

I will begin by thanking the private parties who offered the use of their precious family photographs and the written and oral histories that accompanied the images: Ed and Mary Depin, Yvonne "Dolly" Melanson, Donna Fitzgerald, Mary V. O'Neil and Mary Ellen O'Neil (MEO), Daniel Fernandez, Rita Polselli Ciolfi and Duane Polselli of Marzilliís Bakery. Kate Wheeler provided the picture of Kerr Mill and Scott Rounesville is responsible for the photograph of the mill burning. His keen eye and quick response provides an eerie image of the mill's demise. Lauren Fitzgerald was very helpful in researching information on Lizzie Borden.

The response from some of the public and private organizations in the city was overwhelming. The Marine Museum officers—Melvin N. Lash, executive director; John F. Gosson, curator; and Jasper Coffman, operations manager—were all extremely helpful and generous with their archives and resource materials. A big thank-you goes to Deborah L. Collins, curator of the USS *Massachusetts*; Deb not only provided access to the battleship's archive, but also entrusted me with materials from her private collection of Fall River memorabilia. John P. Harrington and Dennis Abdow were very forthcoming with images and history on Diman Regional Vocational Technical High School, and Father John C. Ozug was a great help on covering the history of the Sacred Heart Parish.

There are several more acknowledgments that merit a special thank-you. James McKenna, proprietor of the Taste of Honey bookstore, was invaluable as a source of materials and inspiration in completing the book. He not only provided a means with which to build my own collection, but was also very generous with the access that he gave me to his personal collection. Thank you, Jim. The other source of material that requires special mention is the Archive of the Dominican Sisters, especially Sister Louise and Sister Mary Patricia. The archive was in the middle of being catalogued and transferred to the motherhouse of the order, in Plattsburg, New York. If I had approached the order a week later, the entire collection would have been shipped, which would have been an immense loss to the content of this volume. The Fall River Public Library was a wonderful source in researching the history of the city. The staff was extremely knowledgeable and helpful in the acquisition of written history and in providing access to the library's image collection. The Fall River Fire Department, including Chief Dawson, and the Fall River Police Department, especially Deputy Chief Thorpe, were both very helpful in this endeavor. Thank you.